C000282761

WIN
LIKE
VIRAT

Abhirup Bhattacharya is a graduate in fashion technology from the National Institute of Fashion Technology (NIFT), Kolkata, and has earned his MBA in finance from Narsee Monjee Institute of Management Studies (NMIMS), Mumbai. He started his career in the apparel sector in Egypt and has a diverse experience serving in IT consulting, payment system and risk advisory. He has his own management blog (Ideasmakemarket.com) which focuses on guiding B-school aspirants and students.

Abhirup's family consists of his father, elder brother and sister-in-law. He is passionate about reading business books, writing stories and watching movies and cricket. He hails from the city of joy, Kolkata, and presently lives in Mumbai.

WINNING LIKE
VIRAT

THINK &
SUCCEED
LIKE
KOHLI

ABHIRUP
BHATTACHARYA

RUPA

Published by
Rupa Publications India Pvt. Ltd 2017
7/16, Ansari Road, Daryaganj
New Delhi 110002

Sales centres:
Allahabad Bengaluru Chennai
Hyderabad Jaipur Kathmandu
Kolkata Mumbai

ISBN: 978-81-291-4606-9

First impression 2017

10 9 8 7 6 5 4 3 2 1

Printed at Thomson Press India Ltd., Faridabad

To my parents and well-wishers

Contents

Prologue

Hi, I am Abhirup. Like most Indians, I am a die-hard cricket fan and I make it a point to watch every game that India plays. A management graduate and a consultant by profession, I am tech-savvy and frequently track scores on my mobile app.

My obsession with cricket started during my school days when the hopes of a billion Indians rested on the shoulders of Sachin Tendulkar. The maestro inspired countless Indians into taking up the game as a career option, some of whom went on to excel. Post Tendulkar's retirement though, I, like many others, felt that cricket will never be the same in our lives. After all, there was no player now for whom we could chant 'Sachin...Sachin....'

It was at this juncture that we saw the rise of a new legend in the making—Virat Kohli. His consistency across various formats and the sheer force with which he plans his innings is a model to behold in the modern era. He has re-captivated the attention of the 1990s' generation to the TV screen just like the time of Sachin when he used to be on the crease. In a cricket-crazy nation, Virat is no less than a superhero.

This book is an attempt to unravel the reasons for his phenomenal success and his philosophy towards life. It is an

attempt to decode and unleash the secrets of this consistent performer so that we all can learn from him and improve our lives.

Happy reading!

Virat Kohli: The Phenomenon and the Role Model

23 November 2006—Delhi versus Tamil Nadu—scored 10 runs
18 August 2008—India versus Sri Lanka—scored 12 out of the
22 deliveries
20 June 2011—India versus West Indies—scored 4 and 15 runs

The aforementioned statistics[*] do not quite give the impression that we are speaking about one of the greatest wizards of the modern game of cricket. Yet, it is this same cricketer who now scores centuries at will and has the power and authority to decimate any opposition on any given day. Yes, we are referring to Indian Skipper Virat Kohli. The scores above reflect his debut scores in first-class cricket, One Day Internationals (ODIs) and Test cricket.

If we simply look at the above scores, these do not quite reflect the other end of the spectrum where Virat stands tall against all the odds. There is something about Virat 'Cheeku'

*Vijay Lokapally. 2016. *Driven: The Virat Kohli Story*. New Delhi: Bloomsbury.

Kohli that makes him standout among other cricketers of his time. This 28-year-old is most likely to break every cricketing record possible by the time he retires from international cricket. His ability to remain calm and chase targets with utmost ease speaks volumes about a person who is arguably the world's best batsman at the moment.

Comparisons have been drawn between him and cricketing legends such as Tendulkar, Brian Lara and Sir Vivian (Viv) Richards and contemporaries like A.B. de Villiers. Yet, each time such a comparison has been put across by a section of the media, Virat has always managed to steer clear of it.

Born to Prem Kohli, a criminal lawyer by profession, and Saroj Kohli, a housewife in a middle-class Punjabi household, he had no connection to cricket whatsoever. Just like any other average individual, he too enjoys a fantastic relationship with his siblings. He loves home-made food despite following a strict diet, and is a 'mamma's boy'. However, what sets apart this guy from everyone else is his sheer appetite for excellence on the 22 yards. He walks into the cricket ground like a gladiator who wishes to be the last man standing.

This chubby little boy started his cricketing career in Delhi and represented his state team in Ranji cricket. He went on to lead the under-19 Indian team to World Cup glory and eventually became a part of the senior side. Was it luck or hard work? Opportunities did not come to him by chance. It is his sheer hard work and dedication that propelled him into the international arena. His commitment on the field has already won him several accolades from across the cricketing fraternity.

Yet, Virat was not always recognised as the most talented player in the team. If we take a look at the initial phase of his career when he made his India debut, many people back then

questioned his attitude and skills. He was just a shadow of the Virat that we see today. What exactly brought this change in his life?

Virat has already led his team as a captain in two major achievements—winning the Under-19 Cricket World Cup and securing the number one International Cricket Council (ICC) Test ranking. His form in the Indian Premier League (IPL) too has been outstanding where he had scored nearly a thousand runs in the ninth edition of the IPL in 2016. His form overseas has been even better. He makes batting seem extremely simple when others find it difficult. Just like bowlers used to fear Sachin Tendulkar's batting, Virat, too, instils fear in the minds of the opposition bowlers. Virat's cricketing exploits can also be compared with a chief executive officer (CEO) who is trying to make a difference in his company. The way a CEO tries to lead his company towards achieving a profitable quarter, Virat aims for the ultimate glory of leading his side to victory every time he leads the Indian cricket team. His aim is simple and clear: charting India to emerge as the best side in all forms of the game.

Virat is the 12th most followed Indian personality on Twitter next to the 'master blaster' Sachin Tendulkar. He is also the third most followed Indian on Facebook with over 33 million fans next to Prime Minister Narendra Modi and Salman Khan. These are no mean counts by any standard and are growing exponentially on a daily basis. In fact in a bid to stay connected with his fans, he occasionally shares his videos as well on social media. Needless to say, they get viral in a very short while. He understands that to connect with Generation Y it is important to maintain and enhance his presence via social media.

Virat is the only batsman in the world to average around

50 in all the three forms of international cricket. His ability to chase down seemingly difficult targets with ease is a model to behold. He is also one of the most successful captains in Indian Test cricket, and in January 2017 assumed charge as the captain of the Indian team for the ODIs and the T20 Internationals (T20Is). Here's what some cricketing legends feel about Virat:

> As of now, Virat Kohli is [the] greatest batsman
> of the world.
>
> —*Sourav Ganguly*[*]

> I love watching Virat Kohli bat. I love his aggression and
> serious passion that I used to have.
> He reminds me of myself.
>
> —*Sir Vivian Richards*[**]

> If I have to pick the best batsman in the world cricket
> right now, only two names come to my mind. One is
> A.B. de Villiers and other Virat Kohli.
>
> —*Nasser Hussain*[***]

[*]http://www.msn.com/en-in/sports/cricket/top-10-quotes-about-virat-kohli-by-former-and-current-players/ar-AAjVilx?li=AAggbRN&%253Boci d=mailsignoutmd#page=1

[**]http://www.msn.com/en-in/sports/cricket/top-10-quotes-about-virat-kohli-by-former-and-current-players/ar-AAjVilx?li=AAggbRN&%253Boci d=mailsignoutmd#page=1

[***]https://www.google.co.in/amp/amp.indiatimes.com/sports/these-quotes-by-legendary-cricketers-tell-us-why-virat-kohli-is-undoubtedly-the-best-batsman-today-254873.html

Virat is a rare talent. I was fortunate to be part of that process of seeing him grow and that gives me immense pleasure.

—Gary Kristen[*]

Virat Kohli is the prince of Indian cricket.

—Ian Chappell[**]

He is just an unbelievable batsman! No need to say anymore.

—Brian Lara[***]

Virat is one of the world's greatest batsmen, combining an unmatched ability to dispatch the ball with pin-point accuracy with exceptional running between the wickets.

—A.B. de Villiers[****]

Apart from playing cricket, Virat is also one of the highest paid brand ambassadors in the country. He owns his own apparel line

[*]http://www.msn.com/en-in/sports/cricket/top-10-quotes-about-virat-kohli-by-former-and-current-players/ar-AAjVilx?li=AAggbRN&%253Boci d=mailsignoutmd#page=1

[**]http://www.msn.com/en-in/sports/cricket/top-10-quotes-about-virat-kohli-by-former-and-current-players/ar-AAjVilx?li=AAggbRN&%253Boci d=mailsignoutmd#page=1

[***]http://www.thehindu.com/sport/cricket/world-cup/world-twenty20-championships-2016-india-versus-australia-t20-match-twitter-abuzz-with-praise-for-kohli/article8404802.ece

[****]http://www.crictracker.com/virat-kohli-is-one-of-the-worlds-greatest-batsmen-ab-de-villiers/

and invests in several ventures ranging from social networking to sports teams to fitness chains. All this at the age of 28 seems almost like a fairy tale to many.

What could be the possible reasons for his phenomenal success? How does he keep himself motivated under all circumstances? What can we possibly learn from his pursuits? How does his mind function to provide such a peak performance every single time? Why are other cricketers not as proficient in scoring runs as Virat?

Can we emulate his traits and mantras in our lives? Yes, we certainly can. This book aims to unravel the secrets of his success and how we can replicate the same in sports and in our daily life.

Let's read on and decode the success recipe of Virat Kohli!

Unbeaten Partnership with Your Mentor

The mediocre teacher tells. The good teacher explains.
The superior teacher demonstrates. The great teacher inspires.

—William Arthur Ward, one of America's most quoted
writers of inspirational maxims

Is it really important to find a mentor? Is finding the right mentor the key to success in any profession? Was having the right mentor and coach the reason Virat could become the phenomenon that he is? Let us delve into the important issue.

To begin with, let us consider the case of Ravi who has just joined work and how he tackles the challenges at the workplace:

Ravi Prakash is a young MBA who has just joined the corporate ranks. He neither knows the exact policies nor is he completely aware of the expectations from him at work. It is his first job after completing his MBA in marketing and has joined as part of the sales team in a pharmaceutical firm. Needless to say, he has already been allocated the target sales to be achieved for the month. He is really perplexed about how to go about and manage the situation in his job.

I am sure many of us have gone through the similar experience at some point or the other in our lives. Almost all of us have wished at that point for someone to guide us, teach us and be with us—in short, a mentor. But what exactly is mentoring?

Mentorship can be defined as a relationship in which the more experienced or knowledgeable person guides the young in any profession. Mentorship has no formal hierarchical structure nor has it any relation with age. It is a relationship that develops out of the sheer **desire** of an individual to learn from another.

To develop a better understanding of the same, one needs to look at the keywords highlighted in bold: It has no relation with age but is only linked with the desire of an individual to learn and the level of expertise of the mentor. The adjective of **desire** is something that is so synonymous with Virat.

Indian cricket was lucky in many ways when Sourav Ganguly got appointed as the captain. This happened at a time when match-fixing allegations had tarnished the image of the game. Sourav with his astute leadership skills and ability to spot talent mentored many young players such as Yuvraj Singh, Harbhajan Singh, Zaheer Khan and Virender Sehwag. These players were the nucleus of the team when India won the World Cup in 2011.

The mentor plays that role in one's life where he is able to essentially drive the growth in the right direction. Quite a few among us, while starting a new job, are often faced with the dilemma of whether we will be successful in our pursuits. In such a situation, it definitely helps if there is someone in our organisation to guide us; someone with whom we can share our concerns and fears. Another good example from the world of sports can be that of Sachin Tendulkar who was transformed

into arguably the world's best batsman by his coach and mentor Ramakant Achrekar. Sachin, in his younger days, wanted to establish himself as a fast bowler. However, it was his coach's vision which saw in him the potential to become one of the finest batsmen of the game. Mentorship is always transformational. If it isn't transforming you into a better version of you, perhaps it isn't the right form of mentorship.

Let us look and analyse the importance of mentorship and mentoring at large and the lessons that can be drawn from Virat Kohli's life.

It is often seen that legends are not born with a silver spoon in their mouth but they are generally the ones who pave way in the face of adversity. The case of Virat Kohli is not different. Virat's family had little or no link with cricket. However, guidance from his father and an able coach in the form of Rajkumar Sharma probably shaped the career of arguably the best batsman in the current era.

During an occasion, Virat had this to say about his coach:

> I never thought I would share the dais with such stalwarts of the game. This is an honour for me. I am lucky to have got a coach like Rajkumar sir. Because of him only I am in the Indian team.[*]

As a young lad, Virat was no different from any other nine-year-old when he first became a part of the West Delhi Cricket Academy (WDCA) under the guidance of Rajkumar. As a coach, Rajkumar not only shaped the destiny of the young

lad but produced a gem for world cricket at large. Delhi has been home to many other Indian players, such as Bishan Singh Bedi, Virender Sehwag, Gautam Gambhir and Ashish Nehra, and young Virat had several players to look up to and carry on the legacy of his state. He eventually played alongside some of them in the national side.

Considering the modern game of cricket is extremely cash rich, it is common for talented cricketers to lose their way. One can easily cite the case of Pakistani bowler Mohammad Amir who was found guilty on charges of spot fixing and had to face a five-year ban from cricket. At the age of 19, he obviously lacked the maturity to take the right decision. Thus, it is often easy to get swayed by the fame and success that is readily available in the world of cricket, but it is the teachings of Rajkumar that has probably kept Virat's feet firmly grounded. His coach and mentor had always protected him from such distractions off the field. During the Under-19 World Cup, advertisers had lined up to sign up prospective India players. His coach was worried that Virat may get distracted with this; however, he convinced his coach 'You will not get damaging reports about me.'[*] It is rare to see such a mature head resting on young shoulders in any field or profession.

LEARNING TIP

There is nothing more common than talent that is wasted.
Be clear on what you want in life.

In the field of management too, it is often said that the importance of a mentor should never be overlooked. In fact

[*]Lokapally. *Driven: The Virat Kohli Story.*

most companies have a structured programme in place to connect young management trainees with the leaders in the company. If we look at companies such as Capgemini, they have regular sessions which connect various management trainees with stalwarts in the company. This helps a great deal as young employees can learn a lot from the experiences of these stalwarts. Furthermore, they can be open about discussing their apprehensions and outlining a clear goal path for themselves. This, in turn, also helps in reducing employee attrition at a later date, thereby creating a win-win situation for everyone.

The presence of a mentor is also important when one goes through a tough phase in life. When the Delhi & District Cricket Association (DDCA) did not select Virat Kohli for the under-14 team, the young boy was uncontrollably heartbroken. He was consoled by his coach and his parents to keep working towards his passion. The result, the following year Virat was a part of the under-15 team. In short, talent, guided with effort and mentoring, is sure-shot gateway to success. It is in such moments of despair that having someone to support you and believe in your skill sets makes all the difference to your future. It is not uncommon to doubt one's abilities; however, it definitely helps to have a helping hand in such moments of self-doubt.

In fact, if we look at any successful business leader, we will be able to look at the importance of a mentor. It is not important to have just one mentor. According to General Motors CEO, Mary T. Barra:

> Some executives credit one or two key people for coaching them to success, but I believe effective mentoring takes a network. Different people see different aspects of us as

we progress in our careers and handle the opportunities and challenges along the way.[*]

The principle of mentoring is fairly old in the context of Indian management as well. The earliest example that comes to the mind is of Chanakya laying the foundations of the Mauryan Empire or that of Dronacharya guiding his disciple Arjuna to become one of the finest archers. The other area that good mentors have an edge over average mentors is in spotting the right talent to be groomed. Not everyone is capable of sustaining a disciplined effort over a long run.

It is important to look at mentoring as an ecosystem and a network that you build and carry forward. People around us bring different skills and we can benefit if we are prepared to learn from them. It is not necessary to make all the mistakes ourselves. Angel investors and venture capitalists while investing in start-ups also bring onto the table a much more valuable ingredient: mentorship. In fact, most of these investors have themselves undertaken the journey of an entrepreneur at some point of time in their career and often follow 'been there, done that' approach. The way it helps an entrepreneur is by ensuring that a clear trajectory of growth is followed when defining their career objectives. Established Indian entrepreneurs, like Sachin Bansal of Flipkart, invest and mentor many start-ups.

This brings us to another question: Can everyone who has an access to mentorship become successful? The answer to this is a definite 'no'. In fact the analogy is similar to a situation that everyone studying in a class taught by the same teacher should finish first. It takes a lot of effort to reach the pinnacle

*https://www.entrepreneur.com/slideshow/249233

of success; mentorship is there to guide you but it does not imply that you don't need to put in the effort. If we consider a three-factor model for success for any individual, it will, by and large, consist of talent, effort and mentorship. Cricketers like Virat Kohli lie in the centre of this intersection.

Figure 1
Success influencer: Talent, effort and mentorship model

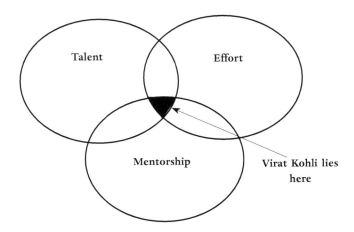

The other thing that sets Virat apart is his ability to find mentors at different points of time in his life. For instance, while starting his career in the international arena, Virat had the opportunity to share the dressing room with veterans like Tendulkar, Laxman, Ganguly and Dravid among others. His attitude to learn by observing these seasoned players and put in the efforts to improve his game, helped him attain new mentors in the form of these legends. The IPL too helped Virat as he was able to share the dressing room with many aces like Chris

Gayle and A.B. de Villiers, among others. The resolute force with which Virat plays each of his innings is also largely a result of his mentor's, that is, his coach's teachings. It is extremely important for anyone in the corporate field to find the right mentor for himself.

Sometimes mentors need to be strict as well. For instance, Virat was dropped from the under-17 Delhi team as his coach felt he was arrogant and was already behaving like a star. Ajit Chaudhary, who was a close friend of Rajkumar Sharma, mentions the following:

> On the eve of the match before the practice, I [Ajit Chaudhary] noticed Virat relaxing on the field, arms crossed behind his head and lying on his back, surveying the others. He was behaving like a star. I announced the squad of twelve and did not name him in the list. Obviously, he was shocked.[*]

LEARNING TIP

Sometimes it is important for your mentor or coach to reprimand you for your mistakes. This helps in course correction for the individual.

Mentorship helps in achieving the following objectives for ourselves:

- Guiding our objectives: It definitely helps if someone is there to guide us and provide us with a clear objective.
- Leading us to a direction: How often have we lost

[*]Lokapally. *Driven: The Virat Kohli Story.*

our way? Everyone surely needs a direction/course correction.

- Solving our queries: Well, we all have queries, don't we?
- Suggesting the best for us: Yup, it definitely helps if we can find someone who always wishes the best for us.

Let us consider a hypothetical scenario wherein a new management graduate joins the corporate ranks. He/she is just one among the thousands of others who are joining the organisation. How will one spot if he/she is the right person to be groomed as the successor?

Virat has a very special quality—the ability to learn from others and not repeat the mistakes. Considering the fame and his achievements, does he really need to take the advice from Rajkumar anymore? Surely Virat is not the first cricketer to have reached the epitome of success at an early age.

It has a lot more to do with the value system that has been ingrained in him both by the teachings of his family and the guidance of his coach. A very good incident to recollect is when Virat gifted his mentor a brand new Skoda Rapid on the occasion of Teacher's Day. How many of us have revisited our school teachers after achieving significant success in our professional career? Talent with humility is what sets apart Virat from the rest.

Virat's respect is not restricted only to his coach but extends towards his opponents as well and of course no one can forget the tribute he paid to Sachin Tendulkar on scoring 50 in World T20 match in 2016 against Pakistan. He bowed down in front of a packed stadium with Sachin acknowledging his protégé. It clearly was a spectacle to watch as it was the new generation of greatness acknowledging the creator. The impact

that mentorship has played in Virat's life can also be deduced from the fact that he shares a very similar relationship with the batting legend. After he struggled during the England tour in 2014, Virat reached out to the maestro to improve his form before the West Indies tour, and it helped him.

It would not be right to say that Virat only looked up to his coach or other cricketing legends as his mentor. His father too had a pivotal role to play in his early life. A middle-class man, his father left no stones unturned trying to fulfil his dream of playing cricket—whether it was driving him to the matches or bringing him to coach Rajkumar's academy. However, his father's untimely death on 19 December 2006 (Virat was just 18 years old then) made the influence of Rajkumar all the more important.

The relationship that Virat shares with his coach is a very special one. Each time he has faced any issue, be it his technique, his confidence or his form, Virat always has had his coach on his side. This in turn has proved vital in creating his success mantra at every challenge. In the India–England series in 2016–17, Virat invited his coach to witness his spectacular innings of 235, which, according to his coach, was arguably one of his best ever. The coaching prowess of Rajkumar was rightfully acknowledged and he was awarded the Dronacharya Award in the year 2016. Though Virat could not attend the felicitation, he made it a point to call his coach and congratulate him.

LEARNING TIP

One should never forget one's roots. It is important to acknowledge the importance of others in your life and try to learn from those around you.

During the occasion of a book release (the book was on him), Virat had this to say about his coach:

In relationships, I always look at *loyalty*. From 1998, I had only one coach [Rajkumar Sharma] and that's never going to change. I have played for one franchise in the IPL [Royal Challengers Bangalore (RCB)] and that's also never going to change. He [Sharma] is the only person I am scared of [getting] a good scolding [from]. I can't say anything to him even now and it comes from respect. And it's always good to have someone like that.*

Let us look at the keyword here: **loyalty**. Does this ring a bell among the readers?

Loyalty—perhaps the one missing link among corporate employees these days, especially since switching of the jobs has become more rampant and almost in every one to two years you are on a new job. So what really happens to that mentor who was guiding you all along in the organisation? Have you not let the person down and the organisation at large? Yet, here is this star cricketer who says he is never going to change his coach. Surely, there are better coaches available globally, what would have happened if he had changed his coach? Can he not afford them? Virat knows it in his heart that without the guidance of his coach at WDCA he would have never been able to achieve the stardom that he has achieved. In fact, whenever he is in his hometown, he always makes it a point to practise at the same ground. That is the mark of the greatness of this Delhi lad.

*https://sports.ndtv.com/cricket/loyal-virat-kohli-scared-of-childhood-coach-rajkumar-sharma-even-now-1476495

LEARNING TIP

It is important to be loyal to the organisation or the team
that you are working with.

However, while Virat was lucky to find that one perfect mentor, it is not at all necessary to have only one mentor. In fact, it is much more helpful if one has multiple mentors as it helps in gaining different perspectives. While mentoring can be a long-term activity, it can equally be of a short duration in a fast-changing corporate scenario. Organising a one-hour session with a renowned personality can help a great deal in nurturing young talent.

For instance, the fitness tips that Virat received during the under-15 Delhi team camp from former Indian spinner Bishan Singh Bedi helped him a great deal. In an interview, Virat told the following:

> I remember when I was taking part in a U-15 Delhi team camp, there was the camp for Ranji team also. Then Coach Bishan Bedi sir told me to give emphasis on fitness and I now know how important it is to be in top fitness in cricket.[*]

LEARNING TIP

Be receptive to small suggestions which will pave the way
for future success and stardom.

[*]http://timesofindia.indiatimes.com/sports/india-in-australia/
interviews/Virat-Kohli-attributes-his-success-to-coach-Rajkumar-and-
Bishan-Bedi/articleshow/12535742.cms

There is no clearly defined age regarding who needs mentoring in a corporate set-up—anybody can in fact; right from the junior-most employee to the CEO. In an ideal scenario everyone needs to be mentored. For instance, even Facebook CEO Mark Zuckerberg was mentored by the late Apple co-founder and CEO Steve Jobs. On his demise, Zuckerberg wrote on his Facebook page:

> Steve, thank you for being a mentor and a friend. Thanks for showing that what you build can change the world. I will miss you.[*]

Even though, Facebook and Apple shared a contentious relationship, yet it did not affect the mentor–mentee relation between their founders. Such is the nature of mentorship that it is also important to do the right kind of self-assessment to understand the kind of mentoring that is actually needed. Consider, for instance, the fact that Warren Buffet, CEO of Berkshire Hathaway, acted as a mentor to Bill Gates, the co-founder of Microsoft.

Those who have been mentored well, often end up being good mentors themselves. As Virat himself found a great mentor in his coach, he understands his role and responsibility in mentoring the new bunch of cricketers who will be playing for India in the coming decade and beyond. Consider, for instance, a player like K.L. Rahul who has flourished under his leadership.

In the England tour of India (2016–17), young 19-year-old English batsman Haseeb Hameed was lucky to have a chat with his role model Virat Kohli. According to reports, Virat suggested to him that he can be good in all forms of cricket and not just Test cricket. Just imagine the amount of good it

will do to the career of the young lad in the future.[*] The young teenager is perhaps Britain's best find for the future in a long time. Haseeb scored an unbeaten 59 in the second innings of the third Test with India despite sustaining a finger injury which impressed many, including Virat, and earned him the nickname 'Little Boycott'.

In fact, Haseeb tweeted the following from his account:

> This was a great moment for me as well. A really sincere and honest guy. Grateful for his time, minutes after his side had won the game.
>
> —2 December 2016, 6:09 p.m.

Imagine the impact on an employee if the CEO of the firm sits with a new joinee on his first day at work. What a tremendous confidence booster it will be! In fact, one would not only attain a more loyal employee but would also have someone who will put his best foot forward each time he is asked to perform.

The good part of mentoring is that it is not necessary to have a formal clearly defined relationship or hierarchy. Most of the time good mentors go out of their way to help young aspirants achieve their goals. Mentoring can also lay the foundation for succession planning in an organisation. It is important to be groomed for the job, and there are few ways better than mentoring in the true sense.

According to a research done in 1995,[**] most of the

[*]http://www.hindustantimes.com/cricket/virat-kohli-s-praise-a-dream-come-true-for-little-boycott-haseeb-hameed/story-lEFAq UohNqrljInKUitP6H.html

[**]Bob Aubrey and Paul Cohen.1995. *Working Wisdom: Timeless Skills* and *Vanguard Strategies for Learning Organizations*. New Jersey: Jossey Bass, pp. 23, 44–47, 96–97.

mentoring happens in business activities in the following stages:

1. **Accompanying:** This involves making a commitment towards the mentee in a caring way and goes a long way in building the relationship.
2. **Sowing:** Ensuring that the mentee is ready to change and this is arguably the most difficult stage.
3. **Catalysing:** Ensuring that the learning that has been encapsulated in the mentee comes into play when the individual is put under pressure.
4. **Showing:** Often in boardrooms, managers suggest that you should have made the presentation in this way or that way; just imagine, for a second, that if instead of suggesting, the manager himself had shown the way, clearly the new joinee would have learnt a lot more?
5. **Harvesting:** Is the mentee finally ready to take the plunge?

Another key to having a successful relation with your mentor is by having a proper communication channel at all times. Whenever Virat faces any doubt with respect to his form or technique, he inevitably interacts with his coach to root out the weaknesses and emerges as a better player. Sometimes, however, the mentor–mentee relationship can go through a rough patch. An important lesson in this regard can be drawn from the incident involving the resignation of Nikesh Arora— the ex-Googler who was widely expected to succeed as the first India-born CEO of SoftBank. In fact if we look at what Mr Masayoshi had to say about Mr Arora, it would surprise many that given this level of mutual respect, what caused him to leave?

> Nikesh Arora and I have been partners in creating SoftBank 2.0. He has been able to help think through our vision,

future growth plans and articulate the SoftBank strategy. He brought world class execution skills to SoftBank, as evidenced in our myriad of investments over the last year, as well as the complex monetisation of our Alibaba stake, and most recently our successful sale of Supercell. I am indebted to him for his contributions.[*]

So what exactly went missing here? It was probably a lack of proper communication which led to a distortion of the vision or maybe a perception about the succession planning could have been the major reason. It is extremely important to keep the channel of ideas and thoughts between the mentor and mentee flowing to maintain a lasting and effective relationship.

Immediately after winning the Under-19 World Cup and bagging the contract for IPL Season 1, several questions were raised on the professional attitude of young Virat and whether he belonged in the international circuit. Questions on whether Virat was mentally and physically ready to be part of the national team were bound to be raised at this level. Cricket being an extremely popular sport, every failure is criticised heavily, and Virat's case was no different. In some ways, his career was at a make-or-break situation. Virat's coach was extremely protective about his protégé at that time and helped him overcome a tough phase in his life. This is what his coach had to say in an interview:

Every coach has a duty just like a parent to keep a check on the progress of his ward. There was phase and he was only 19 years old. Instant stardom after U-19 World Cup

victory and a contract with RCB, it can happen with kids. It's at that point when the coach's role comes into play. You have to give the boy right guidance. It was my duty as he is like my son.*

Mentoring is also about protecting your protégés when the going gets tough and ensuring that they reach their true potential. There is no dearth of talent either in the corporate boardroom or on the cricket field, but what differentiates the best from the rest is the ability to consistently deliver results and keep the same level of performance. A small show of confidence at that juncture can help in moulding any individual towards success.

In this regard, former India captain Rahul Dravid had an interesting perspective at an event organised by the Karnataka State Cricket Association. Rahul said the following:

> Young players should be looking at mentors, not coaches. A lot of youngsters think that they will make themselves world-class players through coaching academies. Coaches focus on concrete issues of the game but mentors go beyond what coaches do. Their focus is on matters including self-confidence and self-perception.**

The presence of a mentor like Rajkumar was certainly instrumental in shaping the mentally strong Virat that the world admires today.

*http://www.dnaindia.com/sport/report-virat-kohli-s-coach-rajkumar-sharma-reveals-how-his-ward-bounced-back-from-ipl-1-blues-2248186
**http://www.firstpost.com/sports/young-cricketers-should-look-for-mentors-not-coaches-dravid-1034273.html

LEARNING TIP

Success in sports as well as in corporate life is a function
of your mental strength. If you have a proper mentor, it will
definitely help.

A minor off-shoot of mentorship can be the buddy programme which many companies practise these days. In the buddy programme, a new employee gets allotted to a 'buddy' to guide him/her and make him/her comfortable in the new organisation. The way a new cricketer feels when he walks into the Indian dressing room for the first time, a new employee feels the same. However, a buddy is often allocated for a brief period and is probably not the right replacement for a mentorship programme.

Virat is fortunate in many ways that his coach also doubles up as his mentor, but a significant bit of it also has to be attributed to his hunger for learning with utmost humility. Let us hypothetically consider in case Virat became arrogant considering the milestones that he has achieved in his career compared to his coach: would he have been able to learn in the same way? The answer is a definite 'no'. Rajkumar never played for India, nor did Ramakant Achrekar, but the gems they have produced is something that the world has recognised. The humility and character that Virat has developed over the years is also due to this effective mentorship. It could have been quite easy for Virat to lose his way if his coach was not there to guide him in his formative years of playing cricket. It is also true that great mentors may not have been great performers and vice versa—the ability to mentor and guide newer professionals or sportspersons is something deeply ingrained within oneself.

LEARNING TIP

Be humble enough to learn. That is the only way you can
correct your mistakes.

I remember working under one of my managers (whom I still regard as my best manager so far) in an IT consulting firm. My manager had this unique approach towards new business opportunities where he used to ask all his reportees and discuss the project before asking them who essentially wants to take up the task. The approach of following such a consultative approach is that it builds enormous trust and enables a manager to be seen as a mentor by his juniors.

If we look at the Theory X and Theory Y of management theories,[*] it also works on the same principle: Theory X managers feel that employees are lazy whereas Theory Y managers feel employees are hardworking by default. It is the breed of Theory Y managers who can play the role of exceptional mentors by guiding their protégés provided they are hungry enough for the success. Virat Kohli is no exception to this rule!

How to know which mentor is right for me?

For any individual working in an organisation, the following steps should be taken to ensure that one has a proper mentor in corporate life.

1. **Know your requirement**: Before finding a mentor it is extremely important to understand why exactly you need the mentorship. The objective of having a mentor needs

*http://www.managementstudyguide.com/theory-x-y-motivation.htm

to be clearly defined in your thought process. For example, if you are in the finance sector, having a mentor who is a marketing guru will not help you in your career. So before finding a mentor, think clearly!

2. **Value the mentor's time**: You should be prepared to ask the mentor exactly what you need to know. A mentor in the company will be available only for a short period of time; maybe just for a period of 30 minutes in a month. In such a scenario, you should know what exactly you want his guidance for.

3. **Work hard**: A mentor can only guide you. He cannot do the work for you. To get the benefit of a mentor, you must yourself put in the effort to succeed.

4. **Expect honesty**: The difference between a mentor and a friend is simple. A friend will tell you what you seek to hear whereas a mentor will want to guide you in the areas where you have made a mistake. So as an individual you should be prepared to hear things which may not always be pleasing to the ears. The question is whether you are prepared to listen and act on it.

5. **Keep the communication channel open**: It is extremely important to keep the communication lines clear. A good practice will be to e-mail your progress on the tasks to your mentor and avail his/her feedback on the same.

6. **Keep the relation productive**: In case you are unable to get a positive response from your mentor and the relationship is no longer productive, perhaps it is time to look for a new mentor.

The importance of mentoring can be further confirmed by the success story of Richard Branson, the flamboyant CEO of Virgin

Atlantic. Branson is one of those people who consider mentoring as the reason for the success of his venture and attributes his phenomenal success to his mentor—airline entrepreneur Sir Freddie Laker.

> If you ask any successful businessperson, they will always
> [say that they] have had a great mentor at some point
> along the road.
>
> —*Richard Branson*[*]

It is important to get perspectives from a mentor who has a wide array of experience across domains. In a country of a billion people, there are definitely people who are far more talented than you or me. The presence of a mentor helps in taking an individual to a different level provided they are willing to put in the effort.

In today's world, students passing out of leading B-schools or engineering colleges earn six- to seven-digit salaries in India. Most of them get so carried away by this success at a young age that they end up losing their way. In fact, they end up spending their salaries in leading a lavish lifestyle and go astray. It is at a stage like this that a mentor can prove to be useful.

In case of Virat as well, he is not only talented but is also someone who believes that talent and skills can be acquired and honed through hard work. He understands his responsibility as a role model and his focus is on excellence on the field. The amount of money that cricket today offers to youngsters is equally a cause for concern. The IPL has already shown its negative consequences with spot-fixing controversy and banning

*https://yourstory.com/2016/09/inspiring-tips-billionaire-entrepreneurs/

of former Indian player S. Sreesanth. Amidst all of this, the presence of Virat as a non-stop performer does generate hope for the next generation of aspiring cricketers. There is little doubt that the presence of the right mentor has shaped the success story of this cricketer.

The Pursuit of Excellence

We should not judge people by their peak of excellence, but by the distance they have traveled from the point where they started.

—Henry Ward Beecher, American social reformer known for his support towards abolition of slavery

What really is 'excellence'? Being the best that one can be in his chosen field of action is one way to look at 'excellence'. However, real perfection is achieved when an individual starts competing against oneself. This is also the driving force behind the success story of Virat Kohli. While many regard Virat as the epitome of consistency over the last few years, in his formative years in international arena he was not quite the force that he is today.

If we go by the records, Virat scored only 10 runs in his debut first-class match played between Delhi and Tamil Nadu. Yet, today he is one of the most feared cricketers by the opposition players and is believed to be one of the finest chasers in the modern game.

Practise makes a man perfect. There is little doubt that Virat has worked hard to reach where he has. His consistent average in all formats of the game is something worth admiring. Malcom Gladwell in his book *The Tipping Point* talks about the 10,000-hour rule.* According to this rule any individual after doing a task for 10,000 hours becomes a perfectionist in that task. Virat seems to epitomise the same fact.

So what exactly are the reasons for his excellence? Harsha Bhogle in his speech at the Indian Institute of Management (IIM) Ahmedabad had talked about the difference between talent and attitude. In his speech he rightfully mentioned the fact that the top one per cent in any profession has the same amount of talent but it is the attitude and the work ethics that make all the difference between them and the rest. It is not talent which differentiates individuals but the amount of hard work that one is willing to put forward.

Here are the hidden principles that one can learn from Virat's pursuit for perfection.

Get the foundations right

Most people often look at the success of an individual with utter disregard to the amount of hard work that has gone in the process of development of that person. The same holds true with Virat. Whenever Virat scores centuries on a consistent basis, many spectators start believing that it is quite natural for a player of his calibre. True, agreed. But does that imply that he is the most skilled player to have played the game in this

*Malcom Gladwell. 2002. *The Tipping Point: How Little Things Can Make a Big Difference*. UK: Little, Brown Book Group.

era? That would negate the hard work he puts in. His work ethics in completing the task at hand is highly commendable.

I truly believe that the one incident that actually proved his mettle was when Virat decided to play on the day of his father's sad demise to save his side from defeat in the Ranji trophy match. That was the day he chose cricket as his life. Virat was batting unbeaten at 40 the previous night with his side staring at a follow on. He lost his father at 3 a.m. in the morning.

Let us put ourselves in Virat's shoes for one moment. Imagine you have lost a dear one and have a make-or-break presentation to a client the following day. Will you have the resolution to execute the presentation with utmost skill the following day? Will you be willing to attend the presentation before attending the funeral? There can only be utmost respect for such an individual and his dedication towards the work at hand. The following day Virat resumed his innings and made a total score of 90, saved his side from follow on with his partner Puneet Bisht (who scored 156) and then went to his father's funeral. He had definitely chosen cricket as his life and was willing to go the distance to achieve his dreams.

Here's what his skipper Mithun Manhas had to say about him:

> We asked him what made him come here. And we also told him that if he decided to go back and be with his family, the entire team would support him. He decided to play. That is an act of great commitment to the team and his innings turned out to be crucial.[*]

[*]http://www.sportskeeda.com/cricket/remembering-the-time-virat-kohli-honoured-his-dying-father-in-the-best-possible-way-by-scoring-a-century

His coach Chetan Chauhan had commented about his performance in the game:

> Hats off to his attitude and determination. It's unfortunate that he missed out on a hundred but what matters today is that how he played, not how much he made.[*]

The determination and desire to succeed often makes the greatest difference between success and failure in our lives. It is this determination that differentiates the best from the rest.

LEARNING TIP

It is important to realise what is important in life and one must be mentally tough to achieve the same against all odds.

It takes time to succeed

There is nothing called overnight success. If some people still believe that it happens, trust me it isn't going to work. Whether we are working in an office or representing our country, we have to consistently upgrade our skill sets. It is for the same reason why professionals often go for certifications; they not only improve their skill sets but also become better professionals.

In a similar way if we look at Virat over the years, he is not someone as gifted as Sachin Tendulkar or Rahul Dravid in terms of technique, but he is certainly someone who has learnt to improve with every game that he has played so far. Consider, for instance, his performance between IPL Seasons 1 and 9.

[*]http://www.sportskeeda.com/cricket/remembering-the-time-virat-kohli-honoured-his-dying-father-in-the-best-possible-way-by-scoring-a-century

Table 1:
Virat Kohli's performance in IPL

Season	Mat	Runs	Highest Score	Avg	Strike Rate	100s	50s	Wickets
2016	16	973	113	81.08	152.03	4	7	0
2015	16	505	82*	45.9	130.82	0	3	0
2014	14	359	73	27.61	122.1	0	2	0
2013	16	634	99	45.28	138.73	0	6	0
2012	16	364	73*	28	111.65	0	2	0
2011	16	557	71	46.41	121.08	0	4	2
2010	16	307	58	27.9	144.81	0	1	0
2009	16	246	50	22.36	112.32	0	1	0
2008	13	165	38	15	105.09	0	0	2

Notes: Mat: matches; Avg: average; * indicates not out.

There is an immense difference in his approach towards the game and the consequent performance. In IPL Season 1, Virat averaged a meagre 15 and the same cricketer ended up as the first one to reach 4,000 IPL runs and scored 900 runs in a single season. It is also notable that his average has increased along with his strike rate which implies that he is not just amassing more runs but also scoring them quickly. The same cricketer whose attitude was questioned in Season 1 was the highest run getter in Season 9, with as many as four centuries to his credit. He feels that he has a responsibility towards leading his side to victory and, hence, any gap in his technique needs to be eliminated as soon as possible.

If we consider young professionals who enter the workplace, after a few years either they move out of the organisation or enter the 'comfort zone' in whatever they are doing. They stop

learning new things and are no longer willing to evolve with time. In fact, they reach a state of mental satisfaction that is so ingrained that work seems to be the only part bothering them in their lives.

A classic case in this point is the Peter Principle* which implies that people get promoted to the level of their incompetence. This management principle formulated by Lawrence J. Peter in the year 1969 implies that people get promoted based on their current skill sets and not on the basis of the skills required in the next role. The result, the higher you go up the corporate ladder, the less equipped you are. Virat seems to defy this law.

So how does he manage to achieve this? The answer lies in his ability to adapt quickly to the situation. For instance, when Virat played the Under-19 World Cup he had introduced himself as a right arm fast bowler, but currently when he plays for Team India he bowls off-spinners. Quite an evolution, right?

Virat even managed to get a wicket in the first delivery of his T20I career in 2011. The match was extremely significant as England had whitewashed India in the Test series with a score of 4–0 in 2011, and the T20 match was considered as an opportunity to regain some of the lost pride. India managed to score a challenging total of 170 runs and England managed to score 58 runs in the first six overs. Skipper Dhoni decided to throw the ball to Virat with Kevin Pietersen on the crease and taking the strike. Pietersen decided to immediately attack the new bowler and charged down the crease; Virat slid his first bowl towards the leg side and Dhoni made no mistake in executing a successful stumping. As the delivery was sliding down the leg side, it was declared a wide, and Virat became

*https://en.wikipedia.org/wiki/Peter_principle

the first cricketer in T20Is to pick a wicket in a delivery that was actually zero.

If we consider the above scenario, there is little doubt that he was under tremendous pressure, but he kept his cool and was able to predict the move of the batsman and adapt his delivery accordingly. In fact, his journey is inordinately different from most other cricketers who get a chance to play at various levels of domestic cricket in India. If we are to plot the career curve of Virat versus other cricketers, it would look something like this:

Figure 2
Success graphs of most players versus Virat Kohli

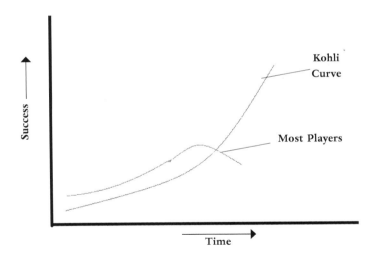

While most cricketers who tasted success early in their career faded away, the pursuit of excellence keeps Virat headstrong and moving ahead.

> Virat Kohli is the best shorter version batsman that I
> have ever seen. He is an absolute genius.

—Kumar Sangakkara[*]

In any organisation, employees should undergo the process of unlearning and re-learning whatever they know. The ability to change oneself with time is what really makes all the difference. History is ripe with examples of companies ranging from Kodak to Nokia who were once market leaders but have now lost their way. Similarly, as individuals we should focus on adapting to the changing environment and perform our actions accordingly.

LEARNING TIP

Never be satisfied with what you have achieved. Keep adapting and improving.

Work when the world is sleeping

Excellence does not come cheap. In fact it demands lots and lots of sacrifice. I would like to quote the reference of the movie *The Prestige* in this regard.[**] In the movie, two magicians try to compete with each other and perfect their art of magic. In the process they sacrifice their personal lives to achieve greatness. One particular conversation stands out:

[*]http://www.ibtimes.co.uk/happy-birthday-virat-kohli-top-10-quotes-about-indias-test-captain-by-former-current-players-1589997

[**]*The Prestige* is a 2006 mystery thriller drama film directed by Christopher Nolan, from a screenplay adapted by Nolan and his brother Jonathan from Christopher Priest's 1995 World Fantasy Award-winning novel of the same name.

Sacrifice is the price of a great trick!

This quote simply amplifies the need to sacrifice to achieve greatness. Let us look at those building successful companies—the journey of entrepreneurs and start-ups. Entrepreneurs not just dream about building something but also end up creating a product that others love to use purely. Consider the story of Flipkart founders Sachin and Binny Bansal—the poster boys of India's start-up story.*They used to stand outside Gangaram Book Stores in Bengaluru, distributing bookmarks to those near the store or who have made a purchase in order to promote Flipkart. How many of us will be able to sacrifice our self-esteem and carry on this task with ease?

How do you think Virat trains himself amidst such a tight schedule? He practises everything in his mind over and over again and then slogs it out in the nets. He analyses which delivery troubles him and then practises the same over and over again till he masters it. Passion is something that will not let an individual go to sleep. Virat exemplifies that passion.

Virat probably has one of the fittest bodies in Indian cricket at the moment and has an enormous number of female fans. The prowess that he exhibits in the field is a result of the tough fitness regime that he follows. In fact, Virat's ability to run quickly and convert the ones into twos and twos into threes has even inspired Australian women's team all-rounder Alex Blackwell. According to her:

I will be looking to practice good cricket shots in front of the wicket, looking to turn ones into twos. Perhaps I

*http://techstory.in/flipkart-story/

gain some inspiration from Virat Kohli and MS Dhoni and the way they have approached the middle overs, that's my job to make sure to turn ones into twos and put pressure on the outfielders.[*]

Was attaining this level of fitness easy? Definitely not. In fact, according to Virat, it was extremely difficult to follow such a strict diet considering he is a huge fan of home-made food.

For the first two months I felt I wanted to eat the bed sheet when I went to sleep because I was so hungry. I was craving taste. I was craving delicious food. But then I saw the results. I felt quick around the field. I would wake up in morning and feel like I had energy.[**]

Virat's diet consists of fish and lamb chops which he absolutely relishes at local restaurants wherever he is on tour. In addition to this, he tries avoiding junk food and prefers drinking only mineral water. Clearly, Virat is extremely cautious about his eating habits. In fact, his approach to fitness can be gauged from the following quote:

It is a conscious effort, to be very honest. It is more like 'Eat, sleep, train, repeat.' If you want to be consistent, you need to be boring with your training, your food and your batting habits.[***]

[*]http://www.cricketcountry.com/news/alex-blackwell-gained-some-inspiration-from-virat-kohli-and-ms-dhoni-on-running-between-wickets-425887

[**]http://indianexpress.com/article/sports/cricket/when-duncan-fletcher-checked-in-virat-kohli-understood-value-of-fitness-4390119/

[***]http://www.firstpost.com/sports/100-squats-weight-lifting-virat-kohli-reveals-his-fitness-regime-2798824.html

He also focuses more on the lower body exercises to stay fit. This in turn provides him the extra stamina while converting the ones to twos in the cricket field. The fitness regime seems to have done wonder for this Delhi lad as he has gained the strength needed to hit those massive sixes which he is nowadays known for.

> I don't do upper body. I only work on my legs for explosive power.[*]

Virat believes in hitting the gym five days a week. This works as it enables his body to also get proper focus. To keep his fitness level at its peak, he understands he cannot skip the regime. Normally he focuses on working out at least two hours at the gym whenever he is at home. In addition to this he also focuses on playing other outdoor games which are also a great way to exercise. He also uses high-end equipment like high-altitude mask (to make his lungs work harder and improve stamina) and technoshaper (which helps in keeping abdomen in shape) as part of his fitness regime.

According to psychiatrist John Ratey, 'Exercise is the single best thing you can do for your brain in terms of mood, memory and learning.'[**] Virgin group CEO Richard Branson believes following his fitness regime provides him with four hours of additional productivity in a day.[***]

[*]http://www.firstpost.com/sports/100-squats-weight-lifting-virat-kohli-reveals-his-fitness-regime-2798824.html

[**]http://health.usnews.com/health-news/diet-fitness/slideshows/7-mind-blowing-benefits-of-exercise

[***]http://www.businessinsider.in/What-11-Highly-Successful-People-Do-To-Stay-In-Shape/Before-her-645-a-m-daily-blow-out-Anna-Wintour-has-already-played-a-game-of-tennis-/slideshow/25600564.cms

There are several advantages of following a strict fitness regime like Virat:

1. **Helps in staying focused**: Unless one maintains proper health, there can never be proper focus at work or any other aspect of life.
2. **Protects against diseases**: It is extremely important to eat well to have immunity from diseases.
3. **Generates extra stamina**: Proper diet helps boosts additional stamina needed to perform the a few extra activities in a day.

Entrepreneurs also apply the same model while starting their venture. They slog it out to perfect their business model over and over again. Just like in any project, the top performers are normally those who put in that extra two per cent effort[*] in their work, similarly the desire to put that extra bit is something that is a rarity. In fact, the motivation to put the same effort can be various—it might be a promotion or a salary hike, but only when it is in pursuit of excellence can the extra effort be put forward in a sustained manner. For example, let's take the example of Elon Musk, the founder of SpaceX. He has a vision to achieve his dream of human settlement on Mars which further drives him on the road to excellence. Tom Peters in his book *In Search of Excellence* refers to three key elements for organisations to achieve excellence: clarity—knowing what you want; focus—the ability to sacrifice and persist with your goals; and connections—driving others to believe in your goals. Virat seems to exemplify the three elements with his dedication and passion.[**]

[*]http://ezinearticles.com/?The-2%-Rule---How-to-Succeed-With-Little-Effort&id=3897362

[**]Tom Peters. 2004. *In Search of Excellence: Lessons from America's Best-Run Companies*. UK: Profile Books.

Now add to that the expectations of a billion people and you will know the motivation that drives Virat to success. If we try to look at the game of cricket, it is not played or won on the ground but in the mind of the individual. Cricket is as much a mind game as it is in executing the right strategy. If we try to analyse what goes on in Virat's mind, it will be a lot of self-talk that runs through him each time he comes out to bat.

> I do not abuse players, I talk to myself, I abuse myself. It's my way of letting off steam. I do it after every century; I do not do it always. I keep telling myself: Improve, improve from the previous match, the previous shot. You can do it.[*]

Our mind consists of two selves—one which questions our abilities and the other which restores our faith in them. For sake of simplicity, let us refer these as self1 and self2. Self1 always poses questions: Am I the right one for the job? Am I good enough at this level? Can I do this? Self2 is more reassuring one. This part of our 'self' reminds us of our best performances and motivates us to do well in the given situation. It is our ability to regulate the two selves that makes the difference.

Should I hit the next ball? Should I wait for the next delivery? What if I get out? Will I be able to chase down this target? Amidst all these doubts, Virat talks to and reassures himself about his abilities and takes the right decision. In case of Virat, his self2 overpowers the anxiety and doubts imposed by self1. According to his own admission, Virat was insecure and anxious in the early part of his career just like any other player, but he managed to overcome it successfully.

[*]http://indiatoday.intoday.in/story/virat-kohli-on-his-183/1/179483.html

I went through the same stuff that every cricketer goes through when he comes in. You are insecure about your place; you make mistakes in your desperation. You want to do really well and you don't really control yourself on and off the field.[*]

If we try to draw a hypothetical relation with his self-belief as compared with other individuals, it will look something like this:

Figure 3
Self-belief in most individuals versus Virat Kohli

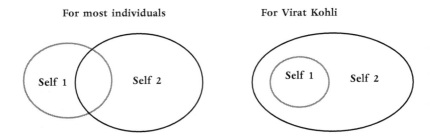

For most individuals **For Virat Kohli**

Self 1 Self 2 Self 1 Self 2

Virat with his faith in his abilities completely overpowers his doubts whereas in case of most other individuals both self1 and self2 are present in almost equal strength. The way it is important to practise on the ground or work hard at your workplace, it is equally necessary to train your mind to face real-life challenges.

*http://indiatoday.intoday.in/ipl2016/story/virat-kohli-recollects-his-early-days-of-struggle-and-anxiety/1/678909.html

Be a quick learner and adapt

The one thing that is so striking in Virat's approach to life is his ability to learn quickly. In fact his learning curve is in direct proportion to the amount of effort he puts in his game. If we look at his success mantras in this regard, we could learn two important lessons:

1. Don't repeat the mistakes.
2. Learn something new every single day.

Both the approaches seem extremely simple but extraordinarily difficult to emulate. However, if one can emulate the same, it will directly drive one on the path of excellence.

Virat combines both these aspects in his pursuit of excellence. He understands his game, analyses his mistakes, learns from them and tries not to repeat them. In 2014, Virat struggled against the English attack. Virat had even taken suggestions from batting maestro Sachin Tendulkar to help improve his performance. In 2016, against the same attack he amassed massive amount of runs. That indicates the brilliance of this young gun.

New Zealand cricketer Kane Williamson in an interview had the following words about Virat:

> His ability to adapt throughout all formats is certainly something to admire. And, it's also something to learn from.[*]

How often have we had to rework on a project or a presentation in office? If we can learn from the mistakes that we had made

[*]http://www.dnaindia.com/sport/report-kohli-s-ability-to-adapt-throughout-all-formats-is-certainly-something-to-admire-says-kane-williamson-2203234

earlier, it will save us enough time to excel in our corporate life and ensure that our time is not wasted in unproductive work. In fact, the right way to look at mistakes is the cost associated with it and doing it right the first time. If we consider a cricket match, Virat only needs to make one mistake to lose his wicket. It is understandable if it is a brilliant delivery that gets him out but he ensures that he does not repeat his mistakes. For instance, even though James Anderson has dismissed him more than any other bowler, his best score of 235 runs was also against the same bowling line-up.

Virat's way of looking at improving each day can best be summarised in his own words:

> Every day's a new day. I always feel that there is a scope for improvement and with every game, I take the plus and the minus as this helps me improvise. There is no substitute to hard work and discipline.[*]

In fact, according to Virat, he did lose his way a bit immediately after winning the Under-19 World Cup. It was at that juncture that he did a lot of introspection to understand what he really wanted in his life. In his own words:

> I couldn't handle what happened after we won the World Cup. People looking up at you and thinking that you were someone who could play for India and just giving you tags like 'blue-eyed boy' and stuff like that. I couldn't take it, honestly. I made a lot of mistakes.[**]

[*]http://indiatoday.intoday.in/ipl2016/story/virat-kohli-recollects-his-early-days-of-struggle-and-anxiety/1/678909.html
[**]http://www.espncricinfo.com/magazine/content/story/516748.html

LEARNING TIP

It is always good to introspect whenever you are in doubt.
Pause a little and think about what's going wrong.

Be focused

The fifth and perhaps the most important aspect of Virat's success mantra is his unflinching zeal for hard work, tenacity and focus that can drive anyone towards success. He keeps his mind clutter free and focuses only on the work at hand.

Now, do you achieve this? The answer lies in having clearly defined measurable goals. When he is planning his innings, he is clear in his mind about the next objective along with the time frame to achieve the same.

How can an individual achieve goals in a similar manner? The secret to this lies in adopting the SMART* methodology of defining goals. This is an acronym that was originally coined by George T. Doran in the November 1981 issue of *Management Review*. According to this theory, while defining any goal, we should keep the following in mind:

1. **Specific:** What is it that you wish to achieve? For Virat, it is all about being the best. Simple, isn't it?
2. **Measurable:** When was the last time you measured your goals?
3. **Assignable:** Are you sure you can do it or you need some support?
4. **Realistic:** Can you achieve it?
5. **Time-related:** When are you going to achieve it?

*https://www.projectsmart.co.uk/brief-history-of-smart-goals.php

If SMART goals are adopted by any individual, it will help them stay focused in their work and achieve the goals within clearly defined timelines. Equally important is the ability to push oneself to go that extra mile.

After winning the series against England, Virat has been more vocal about defining his aim for Indian cricket and his ambitious plans for the future.

> This is just the foundation that's been laid for us to carry on for lot many years. It's just the beginning. It's nothing that we want to achieve; it's not even a tiny bit of that.[*]

LEARNING TIP

Take a small piece of paper and define your goals using the SMART methodology. This will help you stay on track and focused.

Let's break it down

Just like an innings consists of a limited number of overs and targets can be broken down into manageable chunks, so can be any project or a task at hand. Virat Kohli is one of the few cricketers who consistently perform better while chasing targets. The reason for this success is his ability to break down targets into manageable chunks where he does not put additional pressure on himself. In fact, he averages more while chasing targets.

If we look back at 2012, to stay afloat in the Commonwealth

[*]http://indianexpress.com/article/sports/cricket/virat-kohli-test-cricket-india-vs-england-win-4437986/

Bank series India had to chase down the Sri Lankan total of 321 under 40 overs.[*] The Sri Lankan total boasted of centuries from Tillakaratne Dilshan and Kumar Sangakkara. The approach that Virat took was incredible by every count for any 24-year-old. He broke the target into two T20 innings of 20 overs each with 160 runs to score and in the process India chased down the target in 37 overs. Virat scored his ninth ODI century and starred in two century partnerships with Gautam Gambhir and Suresh Raina during the match. He remained not out at 133 of 86 deliveries with an incredible strike rate of 154.65.

Virat approaches targets by clearly planning how many runs he needs to score in every three- to five-over period of the match. He tries to first reach as close to the target as possible before launching the final onslaught.

Sometimes in office we feel bogged down by the amount of workload that we have. How to manage it successfully? The secret lies in the approach we adopt towards breaking down the pile and prioritising work accordingly. It basically implies implementing Value Stream Mapping in our daily activities.[**] It will involve segregating the work into three categories: unnecessary, necessary but can be delayed, and necessary and urgent. Breaking down the work in the Virat approach will help us in achieving our goals in a much better manner.

LEARNING TIP

Whenever you are given any task to approach, try to break it up into small chunks and set a deadline to achieve them.

[*]http://www.espncricinfo.com/commonwealth-bank-series-2012/content/story/555578.html

[**]https://en.wikipedia.org/wiki/Value_stream_mapping

Success is a habit driven by passion

Ever heard the phrase 'the winner takes it all'? Why do you think it happens? It is largely because top performers in any field start playing for pride and with an incredible amount of passion and dedication towards their profession. We have all seen the aggressive Virat on the field. We have also seen the teary eyed and disappointed Virat who refuses to take off his pads if he is dismissed early. The look in his eyes and his body language define what passion truly is and how much he values success. After India's loss to West Indies in the semi-finals of T20 World Cup in 2016, spectators and fans all over the world have seen a teary-eyed Virat Kohli on their television screens.

We have all seen Olympic athletes teary eyed while winning a medal or missing one. The reason for the show of emotion is because of the passion we attribute towards the success. Representing one's country and bringing glory to the nation is the greatest motivation that any sportsman can have. Similarly, a corporate professional would be proud of representing his/her company.

If we speak with the sales head of any multinational firm, we will be able to see the same passion and hunger to stay ahead in the competition and better the sales targets than those achieved in the previous quarter. Ask him/her any question about the product and he/she will be the first one to tell why and how the product is a cut above the rest. At the end of the day, when he/she finally manages to bag the order from the client, his efforts have finally paid off. Let us consider a hypothetical situation.

Iqbal is a sales trainee who had joined the company nine months ago. After being awarded the 'Salesperson of the Quarter' award for two successive quarters, Iqbal has failed to achieve his targets this quarter.

How do you think Iqbal will strike back? In my opinion, he will come back even stronger as a professional as he carries with him the pride of performance. He will analyse what went wrong and probably emerge as a much stronger professional. It is not rare to see the same employee being rewarded in every quarter in a firm. In fact, if we start mapping the employees with respect to their performance, we can see that top performers are often a small minority in any organisation. These individuals have a never-say-die attitude and will never give up even in the face of adversity. They always want to win.

Virat is also an excellent fielder as he always wants the cricket ball to come to him throughout the day. When he wears the pads and gets down to the batting crease, he wants to stay as long at the crease as possible, so that he can drive his team to victory. When he captains his team and sees aggression from the opposition, he, more often than not, lets his game do the talking. He wants to succeed, at all times. If we look at his career at the initial stage, Virat wouldn't hit off sixes normally; however, in the last couple of years he has realigned his game to become a big-shot player. Due to his sheer practice and hard work, Virat has been able to add another level to his game. That's what makes the difference!

In his own words, it is his burning dedication that has rebuilt his career:

I used to stay on the field as long as possible and come back home and stay at home. I totally cut off from everything

else that I was doing for one and a half years. It started to pay off in my cricket.[*]

LEARNING TIP

Be passionate about what you are doing in life. That is the key to success in your chosen field.

Ethics makes a difference

Can you tell the difference between a robber and a businessman? Well, you must be wondering what a silly question it is to ask. Let's think about it a bit more—the objective of both of them is to make money, so where is the difference? It is in the ethics of their acts.

Being ethical is not just a necessity but is of utmost importance without which no journey towards excellence can be complete. There is a reason why organisations such as the Tata Group are looked at with utmost respect in our country while many others are not held in high esteem. If success comes after compromising with ethics, there is no meaning or value for it.

Virat Kohli is one of the few batsmen who will start walking towards the pavilion in case there is an appeal and the umpire has failed to decide. He, of course, can continue to bat, but it is this value system that makes the difference between being good and being the best. However, in the earlier part of his career, Virat was known to have shown dissent several times at wrong umpiring decisions. The Virat we see these days does not lack in aggression but has learnt to control it and channel

[*]http://www.sportskeeda.com/cricket/the-kohli-story

it towards improving his performance.

The result is that though the opposition wants to get him out, they still respect him to the highest extent possible. His performance and dedication make him one of the highly praised cricketers all over the world, including in Australia. When India knocked Australia out of the ICC World T20 2016, Australian newspapers such as *The Sydney Morning Herald* acknowledged it as one of the greatest T20 innings ever and agreed with skipper Steve Smith's remark of it being a 'Virat Show'. Virat scored 82 out of 51 balls to power India into the semi-finals of the tournament.

For the series against Australia in 2017, former Australian player Mike Hussey had already advised the Australian team to not engage in a verbal duel with Virat:

> From an Australian point of view, Kohli is public enemy No.1 and we have to get him out cheaply. If he gets in, he'll go big and score big runs. He's very confident at the moment, he knows the conditions so well and generally if he plays well, India win.[*]

In corporate life we are often faced between choices of doing what is right for us and doing what is right for the company. If one is talented enough, one can find another job no matter how good the current opportunity is. One should never forget the fall from grace of the ex-McKinsey Chief Rajat Gupta who was found guilty on charges of insider trading. The point is, how would we wish to be remembered?

[*]https://sports.ndtv.com/india-vs-australia-2017/dont-make-virat-kohli-angry-michael-husseys-warning-to-australia-1655680

LEARNING TIP

Never compromise your ethics for short-term gains.

Benchmarking the pursuit of excellence

In case of the performance of brands or companies, it is important to analyse the strengths of entities with respect to each other with proper data analysis. Just like Apple is set to dominate the world of smartphones with its one-point agenda of creating state-of-the-art technology (ironically, it accounts for 91 per cent of profit of all mobile handset manufacturers),[*] Virat too aims to do the same. Cricket is an interesting game in which there have been stalwarts like Sir Donald Bradman, Sir Vivian Richards and Sachin Tendulkar. If we try to compare these legends, it will be difficult to determine who among them the best is. For instance, Sir Donald Bradman played most of his cricket against England ending up with a batting average of 99.96. Comparisons had earlier been drawn between Bradman and Tendulkar with Sir Bradman acknowledging that Sachin plays a lot like him.

Comparisons are also being drawn between Virat and Sachin as to who is better. Sachin played 24 years of international cricket; Virat has not even played 10 years: is it correct to compare them? In terms of statistics though, Virat seems to be the only one who can challenge Tendulkar's record of 100 international centuries. Virat has so far distanced himself from

[*]https://www.strategyanalytics.com/strategy-analytics/news/strategy-analytics-press-releases/strategy-analytics-press-release/2016/11/22/strategy-analytics-apple-captures-record-91-percent-share-of-global-smartphone-profits-in-q3-2016

this comparison and rightfully so:

> Honestly I feel embarrassed. It is unfair and Sachin can't be compared with anyone. Comparisons are not valid from my end. I have looked up to him but want to be myself and definitely draw inspiration from him. He is two levels above any player. Sachin was born with talent and I had to work for it.[*]

The admiration appears to be mutual as Sachin is also all praise for Virat:

> Kohli's strength is to be able to analyse the situation and adjust his game accordingly. His match awareness is terrific. To be able to have the vision to what the game would look like after four overs, six overs is commendable. He is able to calculate the required run-rate during chases very well.[**]

Sachin Tendulkar played in an era when the Indian team was heavily dependent on his single-handed batting abilities. Virat, though a match winner, is lucky to have incredible stroke players such as Suresh Raina, Mahendra Singh Dhoni, Ajinkya Rahane, Kedar Jadhav, K.L. Rahul and Rohit Sharma in the team alongside him.

If we have to compare Virat Kohli with his contemporaries, we should compare him with three players—Joe Root, A.B. de Villiers and Kane Williamson. For the purpose of comparison,

[*]http://indiatoday.intoday.in/ipl2016/story/embarrassing-to-be-compared-with-sachin-tendulkar-virat-kohli/1/670546.html
[**]http://indiatoday.intoday.in/t20-world-cup-2016/story/icc-world-twenty20-its-a-joy-to-watch-virat-kohli-bat-says-sachin-tendulkar/1/626358.html

the statistics have been considered till 13 March 2017 for the four players.

Joe Root: At just 26 years of age, this England batsman has all the makings of a great player. An incredibly gifted player, Root has age by his side and can change any game with his wonderful stroke play and timing.

A.B.de Villiers: Arguably the most versatile cricketer in the current era, this South African player is definitely one of the best players in world cricket. He is also a wicketkeeper. His strength lies in playing match-winning innings under critical circumstances and can play any kind of shot to put the field set to shame. At 32 years of age, A.B.de Villiers though is likely to retire before Virat.

Kane Williamson: At 26 years of age, this New Zealand cricketer is the one to watch out for in the future. Kane averages close to 50 in both Tests and ODIs and is decent with the bowling as well.

Virat Kohli: It is fascinating to look at the consistency with which Virat has scored runs in all the three formats of the game with utmost ease and averaging over 50 in all the three formats.

Now if we compare the statistics of the three players, Virat is the only batsman who averages around 50 in all the three formats of the game. So, clearly, at present, his fascination towards perfection and putting in the best effort is definitely bearing fruit. In terms of consistency as well, Virat remains the only batsman to score at least a 50 or a 100 in 3 out of 10 games across the format.

Table 2:

Batting performance of Joe Root

	Mat	Inns	NO	Runs	HS	Avg	BF	SR	100s	50s	4s	6s	Cts	Sts
Tests	53	98	11	4,594	254	52.8	8,352	55	11	27	507	15	65	0
ODIs	83	78	8	3,344	125	47.77	3,918	85.34	9	20	270	28	37	0
T20Is	24	22	4	726	90*	40.33	558	130.1	0	4	74	16	12	0

Notes: Mat: matches; Inns: innings; NO: not outs; HS: highest score; Avg: average; BF: balls faced; SR: strike rate; Cts: catches, Sts: stumpings

Table 3

Batting performance of A.B. de Villiers

	Mat	Inns	NO	Runs	HS	Avg	BF	SR	100s	50s	4s	6s	Cts	Sts
Tests	106	176	16	8,074	278*	50.46	15,022	53.74	21	39	933	57	197	5
ODIs	216	207	38	9,175	162*	54.28	9,160	100.16	24	52	800	194	171	5
T20Is	73	70	10	1,457	79*	24.28	1,098	132.69	0	9	121	52	61	7

Notes: Mat: matches; Inns: innings; NO: not outs; HS: highest score; Avg: average; BF: balls faced; SR: strike rate; Cts: catches, Sts: stumpings

Table 4
Batting performance of Kane Williamson

	Mat	Inns	NO	Runs	HS	Avg	BF	SR	100s	50s	4s	6s	Cts	Sts
Tests	59	107	10	4,937	242*	50.89	9,850	50.12	16	25	544	9	52	0
ODIs	111	105	10	4,362	145*	45.91	5,205	83.8	8	29	411	36	45	0
T20Is	39	37	6	1,125	73*	36.29	916	122.81	0	7	130	15	19	0

Notes: Mat: matches; Inns: innings; NO: not outs; HS: highest score; Avg: average; BF: balls faced; SR: strike rate; Cts: catches, Sts: stumpings

Table 5
Batting performance of Virat Kohli

	Mat	Inns	NO	Runs	HS	Avg	BF	SR	100s	50s	4s	6s	Cts	Sts
Tests	56	96	6	4,491	235	49.9	8,035	55.89	16	14	516	12	53	0
ODIs	179	171	25	7,755	183	53.11	8,544	90.76	27	39	721	81	86	0
T20Is	48	44	12	1,709	90*	53.4	1,268	134.77	0	16	182	33	24	0

Notes: Mat: matches; Inns: innings; NO: not outs; HS: highest score; Avg: average; BF: balls faced; SR: strike rate; Cts: catches, Sts: stumpings

Table 6

Comparison of performance of Virat Kohli, A.B. de Villiers,
Joe Root and Kane Williamson

	100s (%)			50s (%)			Cumulative (%)		
	Tests	ODIs	T20Is	Tests	ODIs	T20Is	Tests	ODIs	T20Is
Joe Root	11.22	11.54	0	27.55	25.64	18.18	38.78	37.18	18.18
A.B. de Villiers	11.93	11.59	0	22.16	25.12	12.86	34.09	36.71	12.86
Kane Williamson	14.95	7.62	0	23.36	27.62	18.92	38.32	35.24	18.92
Virat Kohli	16.67	15.79	0	14.58	22.81	36.36	31.25	38.60	36.36

Rate of scoring 100s/50s among the players: To calculate the rate, the number of 50s and 100s has been calculated as a percentage of the total number of innings for each player.

Virat's contemporaries have a slightly better record than him in Test cricket at the moment; however, given his form, it is only a matter of time before Virat narrows down this gap further and emerges as the clear winner. In case of ODIs, all the four players are in a close fight whereas Virat is a clear winner when it comes to T20Is. *It is incredible to note that he scores a 50 in almost 40 per cent of the time he comes out to bat.* At the same time, Virat also looks at A.B.de Villiers as a role model and has been equally praised by de Villiers in the latter's autobiography.[*] In fact, A.B.de Villiers acknowledges Virat for improving his own game. Clearly, competition and comparison only helps in making Virat better.

Often it is told that an individual can only be good at one skill, yet Virat has shown that it is possible to consistently deliver and be the best in any given situation. In fact, he looks at T20 cricket, including IPL, as a means to improve his performance in ODIs.

> It's different to develop a shot over a period of time, but I don't like to try new shots in every match. I just try to stick to my game plan and score runs sticking to the game plan I have.[**]

[*]A.B. de Villiers. 2016. *A.B. de Villiers: The Autobiography*. New Delhi: Pan Macmillan.

[**]http://www.espncricinfo.com/magazine/content/story/516748.html

In short, he likes to keep his success mantra short and simple:

Keep improving every time!

LEARNING TIP

It is important to apply our skill sets to perform well
in any condition.

The Master Strategist

Strategy is not really a solo sport—even if you're the CEO.

—Max Mckeown, English author and behavioural strategist

Is Virat Kohli really the man for every occasion? What is it that makes him successful every time in whichever role he executes? In my opinion, he plays the roles of a CEO beautifully. Let us decode this further.

> *Lights are on. The bowler comes to deliver at 100 miles per hour. Guess what? It's dispatched for a six. Virat Kohli has done it again!*

Lines like this have become common when it comes to referring to Virat Kohli. Amidst the noise of the sixes and fours and the whistles from the crowd, this gladiator proves that if there is a CEO of cricket, he is rightfully the one. Now imagine the trading floor and people calling the buy and sell discussions on the floor. The CEO looks intensely at the stock pulse of his/her company and tries to decide whether he/she has made the right decision.

The CEO has arguably one of the toughest jobs that any professional can undertake. As the CEO, you emerge as the face of the company. Your decisions get scrutinised by not only the shareholders but also the employees at large. But what makes a CEO really successful in his/her role? It is the ability to visualise what needs to be done for the benefit of the firm in the long run and the will to execute the same.

While every professional aims to be a CEO, not everyone quite possesses the skill sets required to take the tough decisions needed even if it makes one unpopular. Jack Welch, the legendary former CEO of GE, totally transformed the company with clear decision making and his single-point agenda. He wanted GE to be present only in those businesses where it was either the top one or two in the market. It is such clear thinking that makes all the difference.

Are the challenges facing Virat Kohli any less than that of a CEO? The way a CEO has to face the shareholders, Virat has to bear the expectations of the spectators and a cricket-fanatic nation of 1.3 billion people. A CEO is answerable for his/her decisions; so is Virat for his decisions both on and off the field. Here's how Virat epitomises the role of the CEO for a firm:

Being always in the action

Like a CEO who wants to be in the middle of the action all the time, Virat is also very similar in his approach. It is extremely difficult to keep him out of action whether it is fielding, batting or bowling. Steve Jobs, the legendary Apple CEO always used to be in the middle of the action whether it was developing a product or launching the same in front of a large audience. It was the passion to succeed that drove him.

Virat had once remarked:

Cricket is the most important thing to me. So the rest of it pales in comparison.[*]

It is this firm belief that drives him to success and keeps feeding the hunger to succeed even more and push his players. If we believe something is important to us, we always make additional effort to work on it. In case of Virat, cricket is the centre of his existence, and he understands that he has a role to execute and deliver on the field. Virat also analyses the strategy of his opponents on the field and then makes the next move. A CEO also approaches his/her role in a very similar manner. He understands his competitor products that exist in the market, their pricing strategy and a possible response from them.

Whether it is winning the Under-19 World Cup as a captain or ensuring India retains the number one Test position in 2017, Virat has been at the forefront of every activity. He understands his role and the difference that he needs to make to bring a smile to over a billion fans. His aggression on the field and the show of emotions stand testimony to the fact.

LEARNING TIP

Be passionate about the role you are set to perform and you will succeed.

Earning the respect

Every professional needs to earn the respect of his/her team members as that plays a pivotal role in gaining the trust of

[*]https://www.scoopwhoop.com/sports/quotes-by-virat-kohli/

the people he/she works with. You must always remember—whether you are on a sports ground or on the office floor—that you have to earn the respect of your peers as well as opponents. Why do CEOs like Steve Jobs revered so much? It is largely because of the actions they took before emerging as the CEO of the firm. Steve, for instance, being a co-founder of the company, started it from scratch and progressively built it as one of the largest technology giants in history. Even after he got fired from his firm, he ended up building two other companies (Pixar and NeXT) before returning to Apple to create iPhones, iPads and IPods. Jobs made only those products which led Apple into transforming the industry.

In a similar fashion, Virat too started from scratch by performing consistently in under-15, under-19 and domestic circles before attaining phenomenal success in the international arena as a player and now as the captain. His work ethics and dedication earn him the respect from his fellow teammates which makes it easier for him to implement the right strategy in an effective manner.

> Never at any point did I feel like missing a training session.
> I was very keen on improving as a cricketer and as an international player.[*]

When an individual executes his/her job with such dedication, it is natural to be looked up to as a role model by others. There is little doubt that young players look up to Virat with tremendous amount of adulation.

LEARNING TIP

Team building starts with earning
the respect of your teammates.

Being strategic in approach

What actually is strategy? Is it just a way of doing business or is it also about developing newer means to counter the existing situation. The word 'strategy' is coined from the Greek word '*strategia*' which implies the art of troop leading. Strategy had its origins in the idea of battle plans and its implications in defeating enemy forces.

In the modern scenario, generals have been replaced by CEOs and presidents in the corporate world who are marshalling their resources around the globe. Whether it is Apple or Microsoft, the aim is quite simple—world domination and to emerge as the best enterprise on the planet. To do so, correct strategy formulation is needed. Strategy always involves delivering and executing a plan with certain degree of uncertainty. This will not have intricate details but will focus on the execution. It is not possible to define the outcome of every aspect or stage of your plan; so one just needs to build on a high-level plan.

The gentleman's game 'cricket' is no different from a battlefield. Consider, for instance, an intense India–Pakistan match in a World Cup or the Ashes Series between England and Australia. Unlike a war, here the battle is played by the 22 players on the ground with each side aiming to get the better of the other. Cricketers are like gladiators leading their nations and cheered on by the crowd to perform at their best. This involves a wide array of impeccable planning and execution to

emerge victorious at the end of the game.

Virat too looks at the game strategy in this precise manner. For instance, he formulated a plan of playing with five bowlers in Test matches. His thinking was clearly strategic. India has always been a good batting side, but when it comes to bowling outside Indian pitches, it has always struggled. This is especially true on flat-batting tracks. To get the 10 wickets of the opposition on days four and five, it is important to play with five bowlers. Former India Captain Sourav Ganguly too has praised Virat's strategy of going ahead with five bowlers:

> It is an attacking thought, it has worked and that is why we are in such a formidable position right now. Now you have to try and stick to it.[*]

Cricket in the modern era has seen lots of disruptions. It started with the Sri Lankan opening pair of Sanath Jayasuriya and Romesh Kaluwitharana who modified the modern ODI format by maximising the scoring of runs in the first 15 overs of the match. This in future paved the way for the much popular T20 cricket. In today's world, every move that a player makes gets analysed in computer by techies who travel with the team. In such a scenario, to consistently adopt and follow a strategy and deliver results becomes extremely difficult for any individual.

Ever since assuming the captaincy in Test cricket, Virat has been quite methodical in his approach towards both his game and his style. If we consider the move to have Ravichandran Ashwin bowl early as a strike bowler or backing youngsters such as K.L. Rahul or Karun Nair, it is small strategic moves

[*]http://www.mid-day.com/articles/bowled-over-by-virat-kohlis-passion-ganguly-compares-him-to-maradona/16452192

like these that set Virat apart from the rest.

It is important to think clearly to produce results. Virat focuses his entire game plan on factors that he can control. For instance, how an opposition player will bat or bowl is completely beyond his control but he can definitely have his strategy ready according to the opposition's strengths and weaknesses.

Cricket as a game involves real-time action. In such a scenario, the plan that has been created in the dressing room may not get executed at all while on the field. It is extremely important to understand that after a delivery is bowled it takes just a fraction of a second for it to either fetch a wicket or get dispatched for a six. Nevertheless, Virat takes the lead by constantly reviewing his decision and changing his game accordingly. For instance, Virat has been rotating his pace attack with utmost ease: Bhuvneshwar Kumar and Umesh Yadav were being rested in the first and second Test of the series against England in November–December 2016. This helps in keeping all his players fit while building bench strength for future. Having the right strategy in place is a wonderful thing as it helps in preparing one for a possible set of outcomes; however, it is equally important to be adaptable to change.

LEARNING TIP

Be clear in your goals and understand your
objectives before setting a strategy.

Mistakes are meant to guide you

During my first job in Egypt, I remember my boss saying you are free to make mistakes as long as it is new each time. As a 22-year-old, I had no clue what he meant at that time, but now

it makes a lot of sense. As human beings, we all make mistakes, but what is important is that we should not repeat them. This is what sets apart the best from the rest in any business.

Even CEOs make mistakes. For instance, when Google initially came out with the Android operating system (OS), they had approached Nokia to become the first handset manufacturer to implement the OS in their devices. Nokia, being the market leader by a distance, was the natural choice for Google. Yet they refused and decided to carry on with an outdated Symbian OS. This choice had far-reaching consequences with Nokia's handset business declining and eventually being sold out to Microsoft. It is now trying to make a comeback with android as its OS.

In a cricket match as well, at times, players make mistakes and that includes Virat too. However, being a quick learner, he ensures that he does not repeat those mistakes. Mistakes are bound to happen sometimes. As a professional or a sportsperson, we need to acknowledge them and fix them effectively. We should look at mistakes as lessons that prepare us for something better in our lives.

In Virat's own words:

On the cricket field I have crossed the line a few times; so I would like to correct those.... But not really, actually you commit mistakes and learn from them; so there is nothing major I want to change.[*]

LEARNING TIP

Make mistakes, but do not repeat them!

[*]http://www.rediff.com/cricket/report/the-3-mistakes-of-virat-kohlis-life/20160216.htm

The benefits of product management

Curiosity is a unique trait among the top management and CEOs in particular. Do you feel a CEO is the most learned person in the company? In fact, he/she rarely is. However, the art where he/she excels in is in gathering the information that is necessary for taking the right decisions. It is this inquisitive nature that sets him/her apart from the rest.

For example, let's say there is a new product launch that is being planned by the company. From the perspective of the CEO, he/she will be more concerned about certain key aspects that will help in the decision-making process. To do so, he/she will be curious about certain key aspects like cost, technology, business impact and the distribution strategy.

Product management has emerged as one of the key roles in any firm in the current economy. It is not only one of the most challenging roles but also one of the most satisfying ones. The role begins with the conceptualisation of a product to the final execution of the same. Gruelling at times, it can be one of the most rewarding jobs as well

If we compare the traits shown by Virat, he fits in perfectly in the four stages of product management.

Planning: Just like a product manager needs to plan for his/her idea to be a success, Virat too needs to plan not only for his batting but also for his team. As the captain, he, along with the team management, needs to decide the right strategy that will be implemented on that day. If we consider that a product manager has multiple products in his portfolio, he has to ensure which products will be more effective in the given situation. In a similar manner, Virat has to decide the playing combination and ensure that each player is playing in his right position and role.

Forecasting: A product manager has to forecast the sales and based on it prepare the profit and loss statement for it. Based on this forecast, he has to decide if his portfolio has the right mix to succeed in the market. In addition to this, the product manager has to estimate the reaction that can come from competitors or the impact of cannibalisation[*] on the products. In a similar manner as the captain, Virat has to understand and forecast the strategies that will be applied by the opposition to counter his decisions and game plan. The bowling changes that he makes during a match are based on his understanding of the match situation.

Production: This refers to the implementation strategy to be adopted by the product manager for launching the product that he has conceptualised. At times it is largely about the timing that makes all the difference. For instance, the aggressive strategy followed by Paytm[**] from early 2010 onwards is now providing huge benefits which it can reap with transactions growing more than 15 times post 8 November 2016 when the demonetisation drive kicked in.

In cricket too, it is largely about the timing of the move. A bad decision can cost the match and ensure that Virat gets hugely criticised by the audience. However, here too Virat executes his role to near perfection with his aggression on the field matched by his performance to a large extent. In fact, it is a testimony to his success that he remains the only cricketer who averages

[*]Cannibalisation refers to a reduction in sales volume, sales revenue or market share of one product as a result of the introduction of a new product by the same producer.
[**]https://www.finextra.com/blogposting/13576/five-reasons-why-paytm-is-miles-ahead-of-its-rivals

over 50 in all the three forms of cricket.

Marketing: It is not important to make a great product unless it generates sales for the company. To drive sales it is important that there is proper marketing for the product which in turn will help position the product correctly. Press conferences, both before and after the match, play the same role. Both as a captain and a player, Virat here manages the image and morale of Team India. He has to carefully weigh whatever he says as each of his words will be scrutinised thoroughly by the media.

LEARNING TIP

It is important to understand the product
you are managing and your objective.

Accept change

Often we are struck in the midst of a situation where we are unable to accept change and move ahead in our lives. Whether it is our personal life or the professional one, change is the only aspect of our life that stays consistent.

As a CEO, one often needs to take tough decisions like selling off a factory or firing employees to cut costs. It is even possible that as the CEO, one might be asked to leave the firm in the wake of an acquisition or hostile takeover. In fact, as the CEO, as glamorous as it may sound, one is indirectly a servant leader where he has to satisfy not just shareholders but also internal stakeholders. This role involves a lot of mental strength and also often involves spoiling friendships and personal relationships. It might also require sacrificing family life to ensure that results are delivered on time.

Virat too has a similar set of challenges. There had been instances of spectators hurling verbal abuses; for example, in Australia during his first tour in 2012. Under these circumstances, he has to act in a calm manner and accept the change while ensuring that relations are maintained in a proper manner. Virat responded in the most apt manner by scoring his maiden century unfazed by the verbal abuse at the Adelaide Oval. After scoring his maiden test century, he had the following to say 'To give it back verbally and then score a hundred is even better.'* Performance alone should do the talking.

There can be times when the umpire gives an unfair decision; as a player Virat has to accept the decision and move ahead in the innings. In those circumstances, just like a CEO, Virat has to create a vision and instil confidence in the side to win the match with the same vigour. For a strategy to be successful, it is important to understand and define the accountability of all those who are involved. Just like a sales officer is responsible for generating the sales, a cricketer too should understand his role within the team. Virat takes responsibilities for his actions. He believes that it is important to bear the consequences of his action. If we look at the press conferences, he is always the first person to admit his mistakes in case of defeat and owns up to them.

LEARNING TIP

Answer your critics with your performance and adapt yourself to the change.

*http://www.espncricinfo.com/australia-v-india-2011/content/story/548089.html

Stepping into discomfort

How comfortable will you be to step into a 'zone of discomfort'? How open are you to situations which you are completely unprepared for? As a professional, one has to tackle such situations. A more suitable example will be the 2008 financial crisis when there was complete erosion of the valuation of companies in a matter of few weeks.

In a similar vein, cricketers like Virat also have to step into such a 'zone of discomfort' time and again. In fact, when he started his career in the Indian team, he played more as a replacement for senior players such as Yuvraj and Gambhir. Even though he is a middle-order batsman, when regular opener Virender Sehwag got injured, Virat was prompted to open for the team in his debut match in 2008 against Sri Lanka. Virat scored 12 runs out of 22 balls in the match; however, he finished the series as India's second highest run getter with 159 runs in five matches. It is the eagerness to perform and readiness to deliver in such unprecedented scenarios that make all the difference.

In fact, in the midst of a difficult chase, Virat is one of the few Indian batsmen to score consistently. This indicates his ability to tackle pressure in a much better way, for every delivery that he faces as a batsman has the potential to take his wicket.

LEARNING TIP

You grow as an individual when you confront a challenging situation.

Numbers drive business

Just like business is driven by sales and profitability, matches

are decided by the volume of runs scored by the two teams. How different is a stock movement compared to the run rate line graph? Both require the same level of analysis. Except that while a CEO has the advantage of analysts and an able team to make sense of the data, Virat as a player and captain has to analyse the situation real time. If we actually consider the fact that often his decisions have to be made in a fraction of a second, we can deduce the sheer accuracy with which his brain functions and makes calculations.

Figure 4
Virat's performance in ODIs

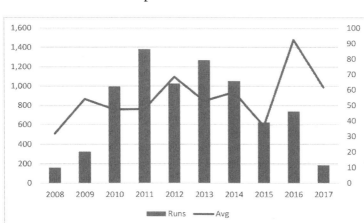

If we consider the graph, Virat's performance has remained consistent over the years. He also has the second highest average in Test cricket history as captain, next only to Sir Donald Bradman. He is also only the fifth cricketer in Test cricket history to score three double centuries in a calendar year. On the first day of the Chennai Test match against England in

2016, Virat was able to get a critical Decision Review System (DRS) right which led to the dismissal of Joe Root for 88. It is this quality of a presence of mind which affects the outcome of the match significantly.

LEARNING TIP

Quick thinking and consistent performance are the keys to success.

Manage your finances

If you felt the prowess of Virat was restricted to the cricket field, well, think again. Apart from being a cricketer par excellence, Virat is also an entrepreneur and invests in numerous companies. Clearly, he is looking at the landscape 10 years down the line when he will no longer be playing and building assets in that regard. This has been a growing trend in Indian cricket with cricketers like M.S. Dhoni, Sachin Tendulkar, Yuvraj Singh and Sourav Ganguly investing in start-ups and acting as angel investors. What sets Virat apart is at the age of 28, his investment spree definitely leaves the others behind.

Virat's investment mantra is simple and clear: Invest in sectors or companies where he himself has an interest. Why? It is largely because he understands those businesses.

If we are to list down his investment philosophy, there are several key learnings that one can take home:

1. **Start planning your investment early**: It is extremely important to start investing at an early age when you have a higher risk appetite and can afford to take the additional risks that are associated with stocks or real estate.

2. **Kohlify your investments**: That is, diversify them. This helps in minimisation of risks associated with it.

3. **Invest in businesses you understand**: Virat is smart in this regard as his investments are focused on areas that he understands—fashion, sports and fitness.

4. **Plan for your retirement**: Cricketers have a short life on the ground. Virat is smart enough to understand that and is investing in a way that these investments provide him sufficient funds post his retirement from international cricket.

5. **Take professional help**: Before investing in any company, Virat seeks the help of professionals to understand the asset quality. Just like a chartered accountant can help you in bringing clarity to your tax savings, a financial planner can bring a lot of clarity to your investment decisions.

If we look at how Virat looks at money, this can be understood from this interview:

> Money is important, but it's not everything. Money adds materialistic comfort to life but it is true what they say— there are some things money can't buy and those things are truly priceless. Time spent with my family, my friends and my dog gives me immense happiness and is above anything money can ever buy. Money is important in life to maintain a good standard of living for your family and children growing up.[*]

It is important to invest, but not get consumed by it. This philosophy can also be seen in the living principle of arguably

[*]http://www.livemint.com/Leisure/Sy49MzxOeobmH6CrUIXl8J/Virat-Kohli-Let-passion-guide-investments.html

the greatest investor in human history, Warren Buffet. He still drives his own car to office and lives in the same house that he had purchased in the 1970s.

Here's a look at the investments made by Virat so far:

A 7,000 square feet luxury pad, a home in Delhi and fascinating cars[*]

Virat has made an investment of about ₹34 crore to own a 7000 square feet luxury pad in Tower C of Omkar Realtors & Developers Project Omkar 1973. Apart from this, Virat also owns a posh bungalow in Delhi and owns quite a few luxury cars, including Toyota Fortuner, Audi S6, Audi Q7 and Audi R8 V10Lmx.[**]

FC Goa

Virat is a co-owner of Indian Soccer League club FC Goa. According to various industry estimates, his investment in the club is about ₹1 crore and is part monetary and part sweat equity. Virat owns a minority stake in the club which is expected to be under 10 per cent. Out here too, he saw the opportunity of football emerging as a more popular sport in India in future and he wanted to cash in on the same.

> On the one hand, I am excited about football as a sport. It is my second favourite sport after cricket and when I

[*]http://economictimes.indiatimes.com/industry/services/advertising/virat-kohli-buys-7000-sq-ft-luxury-pad-worth-rs-34-crore-in-mumbai/articleshow/52788529.cms

[**]http://www.mycarhelpline.com/index.php?option=com_latestnews&view=detail&n_id=956&Itemid=10

realised there is an opportunity to be associated with the
FC Goa team, I took it up.[*]

Former Indian cricketers such as Sachin Tendulkar, Sourav
Ganguly and Indian captain Mahendra Singh Dhoni are also
investors in the Indian Soccer League teams.

UAE Royals

Virat is also a co-owner of the Dubai franchise UAE Royals in
the International Premier Tennis League (IPTL). The league
features ace players such as Roger Federer and is promoted by
Mahesh Bhupathi. The amount of his investment is unknown in
this venture. Yet again, Virat combines his passion with acumen
for business.

I have always followed tennis with great interest and today
I am glad to be part of a professional tennis league team.
I am a huge fan of Roger Federer and with him joining
the UAE Royals, my decision to be on board with the
team was firm.[**]

Bengaluru Yodhas

Virat Kohli is the co-owner of the wrestling team JSW Bengaluru
Yodhas in the Pro Wrestling League (India). The league, one of
the richest free-style wrestling leagues in the world, also features
Indian cricketer Rohit Sharma as a co-owner in another team.

[*]http://www.business-standard.com/article/companies/virat-kohli-looks-at-business-off-field-114092501084_1.html
[**]http://www.business-standard.com/article/current-affairs/virat-kohli-starts-tennis-innings-as-uae-royals-co-owner-in-iptl-115091001110_1.html

I was thrilled on hearing about the Pro Wrestling League and JSW Bengaluru Yodhas. I am no stranger to the city of Bangalore and it is wonderful that I can extend my association by way of the Yodhas.*

Virat, though born in Delhi, plays as the captain for RCB in the IPL. This definitely not only serves to diversify his investments but also extends his association with the city. The association is symbiotic and it also allows the team to leverage the popularity that Virat enjoys.

Wrogn

In November 2014, Virat forayed into another new area—fashion. He along with Anjana Reddy's Universal Sportsbiz (USPL) launched the men's casual brand Wrogn. The brand is available on e-commerce website Myntra and through its own exclusive outlets and Shopper's Stop outlets. This was a marked shift from Virat's earlier investment forays as they were all sportscentric.

The brand is targeted at youth and is built across his personality. In fact, Virat recently promoted the sale on the brand himself on a social networking website with a small video. If we look at the launch strategy of the brand, he did so by a series of Wrogn tweets before eventually disclosing that it was the brand that he is launching.

So guys 'WROGN' is...my breakaway youth fashion brand. Follow my brand@STAYWROGN Hope you enjoyed my

*http://timesofindia.indiatimes.com/sports/more-sports/wrestling/Virat-Kohli-becomes-co-owner-of-PWL-franchise-Bengaluru-Yodhas/articleshow/50122996.cms

tweets today :)—@imkohli

—20 November 2014, 8:04 p.m.

As a lifestyle icon, it makes perfect sense for Virat to foray into launching his own brand. If we take a look at the website for the brand, we can clearly see a vibrant feel along with a look to showcase the various styles. The website also features the following quote to indicate the brand philosophy:

> They picture me as someone who is wrong, and eventually that becomes right after a certain point of time.[*]

According to the official website, the brand currently has about seven exclusive outlets.

Sport Convo

An interesting venture, this London-based tech start-up looks at connecting sports fans across the globe. This was Virat's second venture and has recently received the backing of Real Madrid superstar Gareth Bale.[**]

Virat himself announced the backing of Gareth Bale on Twitter:

> Guys its been a fun day! I would like you all to welcome @ GarethBale11to the @sportconvofamily! #LetsConvo'—@ imkohli

—9 December 2015, 4:00 p.m.

*http://www.wrogn.in/brand

**http://timesofindia.indiatimes.com/sports/off-the-field/Gareth-Bale-backs-Virat-Kohlis-start-up-venture-Sport-Convo/articleshow/50108557.cms

The idea of this venture is quite unique as it enables social networking to connect with fans across various sports teams and further sells merchandise to fans. Virat is also the brand ambassador of this venture.

Chisel

Virat has invested about ₹90 crore (US$13 million) to start a chain of fitness centres and gyms across the country. The brand Chisel is co-owned by Virat, CSE and Chisel India. According to a report, it aims to have 100 centres across the country by 2018. The business works on a franchisee-based model and each franchisee has to pay anywhere between ₹1 crore to ₹3.5 crore along with an annual franchisee fee.[*] Chisel also faces competition from players like SportsFit which is backed by Mahendra Singh Dhoni and global players like Gold's Gym.

The venture targets professionals working in the IT sector and will be located strategically close to IT parks across the country.

> Fitness and good health are extremely important for a happy and successful life. We are happy to announce our partnership with Franchise India as our expansion and commercial partner who would also undertake franchise expansion for the brand.[**]

Stepathlon Kids

Virat, in association with Stepathlon Lifestyle, is also an investor in StepathlonKids. The venture looks at promoting fitness and wellness among children in India. It promotes a 30-day run programme that motivates every child to take 15,000 steps in a day.

> I will be substantially involved in the development and promotion of Stepathlon Kids to achieve our goal to create a healthier nation through the future of India—our kids.[*]

Clearly, Virat has rightfully identified a gap in the market and his business acumen can only be admired.

Now if we try to look at the sectors that he has invested in, all of them relate directly with the personality of Virat Kohli. Clearly, he invests in sectors where he himself can emerge as the brand ambassador and brands that he himself can use. The passion that he carries on the field is also there in his investments. He definitely puts his 100 per cent every single time.

Virat's style of investment follows that of venture capital along with the principle of diversification followed by the retail investors. Thus, he is combining the best of both worlds with utmost ease. Venture capital funds have a tendency to invest in the early stage of start-ups where investors see potential and exit the ventures in subsequent rounds of funding making considerable returns on their initial investment. In my view, Virat is here for the long run. He is an intelligent investor. He understands that in a growing economy, the value of his

[*]http://www.business-standard.com/article/current-affairs/virat-kohli-promotes-a-healthy-lifestyle-launches-stepathlon-kids-116062800919_1.html

investments will only grow multiple times.

As a retail equity investor, I myself have sometimes made mistakes by diversifying in sectors I had little idea about. This resulted in me managing a portfolio with a large number of stocks which led to an issue of not only monitoring the stocks but also continuously rebalancing the portfolio. It eventually led me to concentrate on not more than three sectors and at any time my portfolio would not exceed more than 10 stocks. Virat seems to understand it quite well already. He knows his investments are concentrated in the right sectors.

If we essentially list down his investments, they will look something like this:

Table 7
Investments made by Virat Kohli

Sector	Venture Name	Related with Brand Kohli
Fitness	Chisel, Stepathlon Kids	Yes
Sports	FC Goa, JSW Bengaluru Yodhas, UAE Royals	Yes
Fashion	Wrogn	Yes
Social Network	Sport Convo	Yes

However, as an investor the focus should never be to hold on to the investments if they turn bad. So they should be looked at purely as investments.

LEARNING TIP

Invest in sectors and business you understand.

Building Brand Kohli

All of us need to understand the importance of branding. We are CEOs of our own companies: Me Inc. To be in business today, our most important job is to be head marketer for the brand called You.

—Tom Peters in *Fast Company*[*]

What really makes a brand? On an average if we consider the number of brands that we use on a daily basis, it is no less than 20 or 30 for every individual. Right from toothpastes to soaps to our mobiles, brands touch each and every part of our lives. But how many do we really recognise? Or to put it simply, is a brand just a means to satisfy our needs? Or does it symbolise the identity of who we really are?

How do we actually build a brand in such a scenario? Any brand is recognised by two things—its performance and its consistency in repeating the same performance over a period of time. Now think about Virat Kohli as a cricketer. His value

*https://www.fastcompany.com/28905/brand-called-you

lies in delivering performance on the field in a consistent manner and that essentially builds his brand. Let us analyse the branding process in more detail. Is Virat Kohli a successful brand in making or is he already an established brand?

There is a famous saying that 'brand equity' is as important as the future cash flow of a firm. When it comes to discount strategy of a firm, a good brand is worth more than that. The term 'brand' has its origins in the Old Norse verb *brandr* which means 'to burn'. This relates to an ancient ritual in which animals used to be stamped to claim ownership. In fact cattle branded (or rather stamped) by a farmer of good repute was more desirable than those by a farmer of less repute. This signifies the importance of branding since the early times. A lot has undoubtedly happened on the way from *brandr* to 'brand'. The focus has shifted from searing an animal's flesh with hot iron to creating value for the shareholder. One question though remains relative: What is a good brand? How do we define it and how do we increase visibility?

As always performance drives the way when creating brand equity and Virat Kohli follows the same principle. What is special in case of Virat is that he understands how to create the cash flow out of this equity as well. For instance, the avatar section in Virat's website www.viratkohli.club shows a small cartoon film targeted at children and probably marketed at the under-15 segment. This, in turn, may pave the way for merchandise related to it in future.

Virat definitely understands the science of branding. He has positioned himself in a way in the consumer's mind that automatically assumes dependability and trust. In fact, quite a few cricketers have a certain image associated with them such as Dhoni (Mr Cool), Dravid (Mr Dependable) and Ganguly (Mr

aggressive). Virat captures the consumer's mind by being the single brand that has all the qualities. The growth of Virat as a brand at times is reminiscent of the growth of Facebook. Facebook operates and grows on a domino effect which means that if my friends are there in Facebook, then I too will be joining the platform. Virat too creates a cycle of performance and enhances brand equity in an exponential manner. He is today competing directly not only with cricketers but also with Bollywood celebrities when it comes to advertising revenues.

Virat understands that if his performance dips, the same audience will no longer appreciate his branding instincts. Virat experienced the same after the loss in the semi-finals of the World Cup 2015 against Australia when he and Anushka Sharma faced the ire of the fans. Virat was deeply hurt by the incident and remarked:

> To see those reactions after just one match was very disappointing for me personally. It makes you lose faith in a lot of people.[*]

After Virat's poor performance in T20s in March 2016, many fans trolled the actress and blamed her for the team's defeat. Virat stood up for her and tweeted: 'Shame on people for trolling @AnushkaSharma non-stop. Have some compassion. She has always only given me positivity.' The tweet was voted as the most influential tweet of 2016 and received over 39,000 re-tweets with Virat being lauded for standing by her.[**]

[*]http://indiatoday.intoday.in/story/virat-kohli-world-cup-loss-anushka-sharma-australia/1/429484.html
[**]http://indianexpress.com/article/trending/trending-in-india/virat-kohlis-post-for-anushka-sharma-was-2016s-most-influential-tweet-4413841/

LEARNING TIP

Building a brand is a long-term process; however, one
mistake can destroy it.

As an employee in any organisation, when we perform
successfully, we build a brand for ourselves and are revered for
our services to the firm. This, in turn, creates our brand equity
in the organisation. This is directly linked with the reputation we
carry in the organisation and how it values us. On an average in
any industry, top performers are paid 20–50 per cent higher than
other employees. Is it any different from employee brand equity?

How often do we visit an outlet and ask for the same brands
over and over again? Virat again shows the way in evoking the
loyalty that he himself personifies. Whether it is his association
with his coach or his brands, he maintains them for the longest
possible period. In a similar manner, employees too can maintain
a loyal relationship with their employer by ensuring that they
serve the longest period possible with them. To achieve the same,
companies recognise employees on their work anniversaries and
recognise them with monetary/non-monetary incentives.

In short, to build a brand for yourself, you need to consider
the following aspects:

1. Start by defining your brand. What is Brand 'You' all about?
2. Are you willing to put the effort to deliver successfully each
 time?

The remarkable brand that he has built for himself has definitely
generated significant brand equity for Virat. According to
Sportskeeda,[*] he is worth about US$20 million, though Forbes

[*]http://www.sportskeeda.com/cricket/virat-kohli-salary-net-worth-
endorsements

quotes his net worth at about US$11.2 million.[*]

Being a grade A cricketer, Virat draws about ₹1.25 crore (US$190,000) as retainer fees on an annual basis from the Board of Control for Cricket in India (BCCI). Apart from this, he also earns ₹5 lakh for each Test, ₹3 lakh for each ODI and ₹1.5 lakh for each T20. His salary also includes a performance bonus of ₹5 crore.

In terms of his endorsement fees, he charges ₹2 crore per day for an endorsement which is higher than even Mahendra Singh Dhoni who charges ₹1.5 crore per day. In fact, it is equal to the fees charged by Sachin Tendulkar. Virat currently endorses 13 brands[**] against 15 brands endorsed by Mahendra Singh Dhoni. If we assume that each endorsement will involve shooting and press conference involving three to four days, it implies Virat makes somewhere between ₹80 crore and ₹100 crore from endorsements alone. Considering that he is just 28 at the moment, his income from endorsements is only going to increase with time once Dhoni retires from all forms of cricket.

If we closely look at the brands that Virat endorses at the moment—they are all looking for a youth icon and Virat fits the bill perfectly. He has recently become the first Indian sportsperson to have a ₹100 crore deal with a single brand when he was signed up by Puma. On the occasion, Virat once again reiterated his long-term association with any brand he endorses:

Both Puma and I are committed to a long-term partnership.

[*]http://indianexpress.com/article/sports/sport-others/virat-kohli-forbes-list-sania-mirza-saina-nehwal-money-earnings/

[**]http://brandequity.economictimes.indiatimes.com/news/advertising/with-13-brand-endorsements-virat-kohli-is-the-newest-joinee-of-the-rs-100-crore-club/51523291

I am impressed by the way Puma has gained popularity and market leadership in India in a short period of time.[*]

Can an employee become the brand for the company? Yes, definitely. Top performers in any firm become effective brand ambassadors for the company. As an employee, you represent and uphold the image of the firm to an outsider and by consistently performing at a peak level, you make yourself an asset to the firm. Virat too is reaping the benefits of his peak form.

If we consider a lifecycle curve with respect to Virat, his current position will look like this:

Figure 5
Mapping of Virat Kohli in the product lifecycle curve

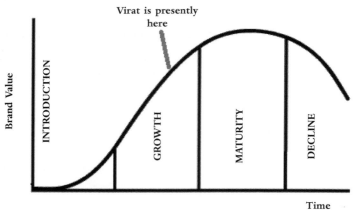

In any organisation the growth rate of top performers is far higher both in terms of hike provided and of the facilities that

[*]http://timesofindia.indiatimes.com/sports/off-the-field/virat-kohli-strikes-rs-100-crore-deal-with-puma/articleshow/57243206.cms

they enjoy from the firm.

A powerful brand should look at creating products that are desired. The difference between desire and need is simple: you cannot create a substitute for desire, you can only enhance it. The same holds true for Virat. Owing to his consistent performance in all the three formats of the game, Virat brings across a sense of fulfilment in the audience who come to the stadium to watch him play.

Product life cycle is the cycle through which every product goes from introduction to withdrawal or eventual demise.[*] The theory was developed by Raymond Vernon in response to the failure of the Heckscher–Ohlin model to explain the observed pattern of international trade. Product lifecycle curve defines a pattern: every product goes through three phases—initial adoption, reaching its peak and final decline and phasing out (in case of the classics, the pattern is regenerated without phasing out). Brands and companies go through similar curve in their life cycle. The question, therefore, is: Can a brand/product defy this process and challenge it? Perhaps it is possible.

Figure 6
Defying product lifecycle curve

*http://economictimes.indiatimes.com/definition/Product-Life-Cycle

Let us consider the first graph: Consider three points A, B and C at random and point D representing highest demand. Point A represents the stage when the popularity of the product is rising, point B represents the stage when the rate of demand is highest, point C represents the stage when the rate of growth has started to decrease and point D indicates when the demand has reached its maximum. Now the point to note is decrease in the rate of demand after point B; so the real chance of redefining the product lifecycle curve is if we can change its pattern before it reaches point B. How do we achieve it? Suppose the company launches a new superior product (using the same logo and brand to retain the market) at the same price and stops producing the existing product (refer point A' in new curve). This sounds an extremely difficult proposition considering the huge R&D costs involved in developing the superior product, but higher sales will negate the costs involved. If a new improved product is introduced in every interval, the hypothetical graph should look like the dotted curve (refer B' and C').

This model might not work for traditional players; however, it will yield tremendous results for companies looking for constant innovation. Virat Kohli adopts the same approach. By consistently improving his game, he makes it a point to remain indispensable to not only the team but also advertisers at large. He understands that cricket is the medium which has given him stardom and to retain the same, he needs to keep performing. His earnings from endorsements have not affected his gameplay and he has only moved from strength to strength.

LEARNING TIP

Build a brand that is consistent with your identity and the emotions you convey.

Let us look at the emerging dimension of branding in our times: we have the tremendous phenomenon of social media. Almost any brand these days will use social media and analytics to understand how its customers and consumers perceive the brand. In fact, companies ranging from HUL to Volkswagen are relying heavily on social media to make their campaigns go viral. But going by this trend, can we conclude that social media makes or breaks a brand? Does the number of likes on your fan page indicate the success of the product/service you are trying to sell? Can anyone say for certain that a company with 300,000 likes or 40,000 followers will offer a greater value proposition for the customer than a start-up? What if that start-up is the next LinkedIn? Are we not missing an opportunity as potential investors?

If we look at the other end of the spectrum, we can find one company that does not believe in social media ruling the mobile economy and emerging as one of the leading brands of the digital era: Apple! Yes, Apple does not have an official Facebook page or Twitter account. It does not believe that it's needed. It only believes in creating great products, the ones that we all desire. The moment you create such a product, customers themselves act as your biggest marketers, thereby, also reducing your marketing expense.

These are questions which are undoubtedly difficult to answer. However, Virat understands the importance of social media quite well. He has a dedicated team that manages the social media presence for this star cricketer.

Let us consider his presence in social media in major networks:

Facebook: 33 million+ fans

Twitter: 13 million followers

LEARNING TIP

It is important to manage your presence in social media and connect directly with your users.

As a national icon for sports in India, Virat also understands his social responsibilities. He feels that the recognition that has been given to him can be used to promote social causes. As a responsible citizen, he feels it is his right to express himself for the betterment of the society, whether it is women empowerment or pollution in Delhi. Let us look at some social issues that he has raised so far:

Women safety and gender equality

In an interview to a daily newspaper, Virat offered his views on women safety and gender equality. He stated the following:

> It has obviously been a major concern for a long time, especially rapes, molestations and eve-teasing. It is very disrespectful to look at women in that way. It comes from the kind of society that we have built over the years where women have always been known to be treated as inferiors. How can this be done? This mentality is disturbing and needs to be condemned.*

It is wonderful to know a well-known cricketer standing up for women's rights in the present era. It is especially significant as Virat's hometown Delhi is regarded as one of the most unsafe cities in the country.

*http://www.thehindu.com/sport/cricket/virat-kohli-bats-for-gender-equity-respect-for-women/article7977389.ece?homepage=true

Message on Mother's Day

Virat delivered a heartfelt message to all his fans on Mother's Day and asked them to love their mothers unconditionally. Along with this, he also shared a photograph with his mother. It is really admirable to see the simplicity of this stylish right-handed batsman. In a short video, he said the following:

> A mother's love is always unconditional and you should love your mothers back unconditionally. They are the biggest blessings of the god, so appreciate it. And I hope you all have a wonderful Mother's day, God bless you all.[*]

Demonetisation drive

While India remains divided on the demonetisation issue, Virat has been quite verbal about the move by Prime Minister Narendra Modi and has even hailed it as the greatest move in Indian history in recent times.

> I was actually going to pay my hotel bills in Rajkot and I was taking out the old money and I forgot that it isn't of any use anymore. I could have actually signed on it and given it to people, they are that useless now.... For me, it is the greatest move I have seen in the history of Indian politics by far, hands down. I have been so impressed by it; it's unbelievable what's happening.[**]

[*]http://www.bollywoodlife.com/news-gossip/virat-kohli-just-proved-he-is-a-true-gentleman-with-this-message-for-all-the-children-and-mothers-across-the-world-watch-video/
[**]https://www.telegraphindia.com/1161117/jsp/sports/story_119701.jsp#.WGlnY_l97IU

Pollution levels in Delhi

Virat has been quite verbal with respect to the rising pollution levels in Delhi. In a video posted on a social networking website, he told the following:

> The pollution levels in Delhi are just horrible at the moment. Schools are getting closed, sports events are getting called off, and it's a situation which is only getting worse by the day. If we don't act, there's [going to] be a lot of problems in the future.[*]

It is good to see someone like him taking a stand. What really strikes about Virat is that he is not afraid to speak his mind. It is this frankness that actually sets him apart.

Molestation of girls in Bengaluru on the New Year's Eve

Virat has condemned the unfortunate incident of the molestation of girls in Bengaluru on New Year's Eve in 2017. In his social networking account on Twitter, he posted a video mentioning the following:

> I would like to ask a question, God forbid if something like that happened to someone in your family, would you stand and watch or would you help? These things are allowed to happen because people stand there and watch it and they are absolutely fine with it. That's why these things happen to a girl. Just because she is wearing short clothes. It's her life and it's her decision, her choice and for men to accept that it is an opportunity to get away doing

*http://www.deccanchronicle.com/sports/cricket/081116/delhi-smog-virat-kohli-issues-plea-to-rid-national-capital-of-pollution.html

this and men in power defending it is absolutely horrible.*

Clearly Virat has not only shown his concern but also his responsibility as a citizen. This further enhances his reputation as a social brand.

Corporates practise corporate social responsibility (CSR) activities; individuals too should contribute in what I refer as 'individual social responsibility'. Virat has shown considerable regard in this aspect and has been associated with several NGOs, including an old-age home Abhalmaya in Pune where he has donated 50 per cent of his IPL match fee (RCB versus Rising Pune Supergiants, 2016). He has also tied up with an NGO ABIL Foundation to further assist the old-age home.

In addition to this, he has also set up the Virat Kohli Foundation to support underprivileged kids. On the occasion on setting up his foundation, he said the following:

It has been in my mind since very long time. But I was going through transition phase, so could not start off with the venture. Now, I feel it's the right time to get on with it. I know it takes time but I think I have matured enough to start an organisation for children who cannot afford education or play any sport. If I am able to inspire kids to achieve something that will be my biggest achievement.**

LEARNING TIP

Unless your brand is aware of the responsibility that it owes, it will not be sustainable in the long run.

*http://www.firstpost.com/sports/bengaluru-molestation-virat-kohli-bats-against-harassment-of-women-after-disturbing-incident-3191088.html
**http://timesofindia.indiatimes.com/sports/off-the-field/Virat-Kohli-to-start-charity-foundation-for-underprivileged-kids/articleshow/19094868.cms

Lessons in Leadership

Men make history and not the other way around. In periods where there is no leadership, society stands still. Progress occurs when courageous, skilful leaders seize the opportunity to change things for the better.

—Harry S. Truman, Former President, USA

What is leadership? When asked this question, almost everyone will feel it is the ability to lead others which defines leadership. But is it really that simple? Let us consider a small situation:

John is a manager in VCX Corp. He has about 10 individuals directly reporting to him. John uses his authority to command these 10 people and gets his work done. He is never directly involved in the activities except for ordering his subordinates.

If we look at this scenario, John is leading his team but is he really a leader? Using the authority to lead others is not really a sign of leadership.

Leadership, in my view, is a natural trait that has nothing

to do with either age or experience or authority. It is a social influence that one exercises to achieve a common goal. Let us consider the example of Elon Musk, the CEO of futuristic companies such as Tesla and SpaceX. He is even building a new mode of transportation called Hyperloop. Now imagine him asking his subordinate to do an activity. Will he need his authority to make the person complete the task? Definitely no. This is what we call being a natural leader. When an individual leads by example, others follow him even if he/she does not have any formal authority.

There have been various brilliant captains in cricket. There have been the likes of Clive Lloyd, Imran Khan, Steve Waugh, Arjuna Ranatunga who come to mind immediately. If we look at the Indian context, we come across stalwarts such as Tiger Pataudi, Kapil Dev, Mohammad Azharuddin, Sourav Ganguly and Mahendra Singh Dhoni. This is a league of gentlemen who had led their side with distinction and had managed a complete transformation of the team.

Kapil Dev with his World Cup–winning captaincy in 1983 helped in popularising the sport in India which went on to emerge as the top cricket-crazy nation in the world. However, the image of the Indian team was always like tigers at home and rabbits abroad. India simply failed to win enough matches on overseas soil. Things changed post 1999–2000 when Sourav Ganguly was named the captain. He took over the reins of Indian cricket at a time when it was at the lowest with the match-fixing controversy involving Azharuddin, Jadeja and Mongia.[*] Sourav managed to instil faith in Indian cricket by taking the team to the finals of World Cup 2003. The team had notable youngsters

[*]http://www.thehindu.com/2000/11/01/stories/01010006.htm

such as Yuvraj Singh, Harbhajan Singh and Virender Sehwag who formed the backbone of the team when India won the World Cup eight years later in 2011 under Dhoni's leadership.

India under Mahendra Singh Dhoni was a different side all together. It became the number one side in Test cricket for a period of 18 months, won the inaugural ICC T20 World Cup 2007 as well as World Cup 2011. Amidst all this, there was a young Virat who was part of the World Cup 2011 winning side. It was not new to him; he had already led the under-19 team to victory as captain in Kuala Lumpur in 2008. Perhaps it was just the start of the cricketing career of this legend in the making. Virat as the captain of the Indian team will now have to continue with the success of both these captains—Ganguly and Dhoni—going forward, and seems to be doing pretty well in that aspect.

Signs of leadership in Virat

Stint in domestic cricket

Virat has always shown himself to be a natural leader in the team. In the year 2003–04, when he was appointed as the captain of the Delhi under-15 team, he scored a 50 against Himachal Pradesh and followed it up with his first century against Jammu and Kashmir. Clearly, he found himself fit for the job and the challenges that lay ahead. Virat captained the team in the Polly Umrigar Trophy (2003–04) and finished with 390 runs from five matches. It was a clear sign that he was not getting weighed down by the expectations from captaincy in the early days of his career.

LEARNING TIP

Being the leader should complement your performance. It should not weigh you down.

Stint as the India under-19 captain

Virat also enjoyed the glory of winning the Under-19 World Cup as captain. A successful captain or a leader is one who shares the glory with his team while taking the lead in accepting the blame in case of defeat. It is significant that even at that age, he remembered to share the triumph with the rest of the team.

> It was a great effort by the whole team. I would particularly like to thank our coach [Dav Whatmore], who has been a great support system for us and taught us to believe in ourselves. I feel absolutely wonderful, I am happy, and I do not have words, we believed in ourselves and played as a unit. Marvellous effort by South Africa, a dream final, and thank you team South Africa.[*]

His mantra for winning the cup was simple: Let us play as a nation. Play the best game of your life.

LEARNING TIP

Learn to play and win as a team and respect your opponents.

According to his teammate Siddharth Kaul, Virat was amazingly focused even at that age. In the book *Driven: The Virat Kohli Story*, he says:

[*]Lokapally. *Driven: The Virat Kohli Story.*

> Virat was astonishingly aggressive and focussed. He hated losing. He simply talked about winning the final, and sometimes it would lead me to wonder if there was anything other than cricket that engaged his attention.

It is extremely important to back your teammates and believe in their abilities. Things will go wrong sometimes, but backing them and supporting them at that juncture helps in building the team.

Stint in IPL as captain

Virat's performance in IPL and captaining a side that comprises players like A.B.de Villiers speak volumes about his skill sets. Though he has not yet been able to win the IPL trophy, he finished IPL Season 9 in 2016 as the highest scorer with four centuries in the season and was awarded the orange cap. He also led the team to the finals in the same season before losing to Sunrisers Hyderabad in Bengaluru. Even on this occasion, though disappointed, Virat maintained a composed look and said the following:

> Definitely proud of the way we played this season. This was for people of Bengaluru. They have supported in worst of seasons. We would have loved to be on [the] other side of [the] result.[*]

A good leader is one who handles disappointments and success with equal ease. Clearly, this is the hallmark of a player who does not bow down to pressure.

[*]http://www.thehindu.com/sport/cricket/ipl/rcb-captain-virat-kohli-on-sunrisers-win-in-ipl-2016/article8664153.ece

Stint in international cricket as captain

Virat's ascent to captaincy was in an unexpected manner when Dhoni decided to step down as captain before the final Test in India's tour of Australia in 2014. Yet again, Virat grabbed the opportunity with both hands. In an interview to an English daily, Virat admitted to being emotional when Dhoni announced his decision to retire from Test cricket. Of the 25 Test matches that he has led, India has won 16 of them, making him the third most successful Test captain along with Azharuddin and behind Sourav Ganguly and M.S. Dhoni. The main reason behind this success has been the way that he approaches the game as the captain. He has so far led the side in 20 ODIs, winning 16 of them, and has the highest winning percentage among Indian captains who have led in 10 or more matches.

Virat's record as captain so far is mentioned in the following table:

Table 7
Virat's record as captain

	Mat	Won	Lost	Tied	Draw	Win (%)	Loss (%)
Test matches	25	16	3	0	6	64	12
ODIs	20	16	4	0	0	80	20
T20I	3	2	1	0	0	66.67	33.3

Notes: Mat: matches; NO: not outs.
Data is updated till 13 March 2017.

His own contribution as batsman has also been remarkable as a captain. While most players struggle after assuming the role of captaincy, Virat's batting is thriving after becoming the captain.

Table 8
His batting record in Tests (as captain)

Year	Runs	Tests	Inns	NO	Avg	100s	50s
2014	256	1	2	0	128.0	2	0
2015	640	9	15	0	42.7	2	2
2016	1,215	12	18	2	75.9	4	2
2017	282	3	6	0	47	1	0

Notes: NO: not outs; Inns: innings; Avg: average
Data is updated till 13 March 2017.

Table 9
His batting record in ODIs (as captain)

Year	Runs	Mat	Inns	NO	Avg	100s	50s
2013	332	8	6	1	66.4	2	1
2014	518	9	8	1	74	2	2
2017	185	3	3	0	61.7	1	1

Notes: Mat: matches; Inns: innings; NO: not outs; Avg: average
Data is updated till 13 March 2017.

Table 10
His batting record in T20Is (as captain)

Year	Runs	Mat	Inns	NO	Avg	100s	50s
2017	52	3	3	0	17.3333	0	0

Notes: Mat: matches; Inns: innings; NO: not outs; Avg: average
Data is updated till 13 March 2017.

If we consider Virat's outlook towards captaincy, one can easily see him as a leader who does not put undue pressure

on his teammates and wants to lead from the front. In his own words:

> As a captain, I always tell my teammates that I will never ask them to do something that I can't do first. For example, during that Test in Adelaide, the night before the fifth day, I gathered everyone and told them we were going for the target. If I say that and the next day I go out and make 20 runs in 80 balls...that does not connect me to the team. I first convince myself if I can do it, and only then I ask my teammates to go for it. When everyone is working hard and someone takes things for granted, I do speak to him. He is bound to realise his mistake when there is an atmosphere of honesty in the dressing room.*

If we consider his approach of leading from the front, there is a lot to be learnt here. In his first Test match as captain against Australia, Virat scored 141 in the second innings (his second century of the match) and though India lost the match chasing a target of 364, he had already proved his mettle. Equally important is the fact that despite knowing that the target was stiff and the match could be lost, he gave it his best effort. He understands that as the captain he needs to lead with his performance.

Similarly, as a leader in the corporate boardroom, one needs to understand that unless we ourselves perform, the team will not be able to deliver results. Great leaders always strive to win. Do you think when Elon Musk dreams of human settlement

*http://www.thehindu.com/sport/cricket/indian-cricket-test-team-captain-virat-kohli-on-captaincy-bowlers/article7981443.ece

on Mars, he does not risk failure? Of course he does. However, what matters is his ability to visualise the possibilities.

LEARNING TIP

If you wish to win, you have to take adequate and calculated risks in life.

It is important to understand how former players rate the captaincy skills of Virat to further decode the leadership skills of this Delhi lad:

> Kohli is a fantastic leader and his passion for winning
> Test matches is unreal. And I think with his ability, just
> think about the Test match in Adelaide, when the captain
> stands up and gets back-to-back hundreds and the second
> hundred was even better than the first one. So, when you
> have a captain who wants to achieve so much, you can
> expect good things from this side.

> —*Sourav Ganguly*[*]

> To become a good player you need talent. To become a
> great player, you need an attitude like Kohli.

> —*Sunil Gavaskar*[**]

[*]http://indiatoday.intoday.in/story/sourav-ganguly-virat-kohli-test-captain/1/824575.html
[**]http://www.ibtimes.co.uk/happy-birthday-virat-kohli-top-10-quotes-about-indias-test-captain-by-former-current-players-1589997

Leadership traits of Virat

To succeed as a captain Virat Kohli displays various leadership styles and moulds himself according to the situation. If we look at his management style, we can see traits of the following leadership styles:

Charismatic leadership

For a leader to succeed in today's corporate era, you need to win the confidence of your followers. It is of utmost importance that your team members feel comfortable in your presence. Virat's innings of 235 as captain against England in the fourth Test in December 2016 implied that he truly believes in leading the team by example.

Participative leadership

In this type of leadership, the leader consults his team members before making a decision. The consultative approach taken by the leader helps in building a more cohesive unit for the future. Virat is known to be a participative leader and maintain a calm influence in the dressing room. He consults his team members and also enjoys the confidence of other players. Former captain M.S. Dhoni too used to follow this principle and would consult Kohli during matches:

> I have already started using him [Kohli] more. If you witness a match you will see I have more interactions with him on the field because two individuals of course will conduct in different ways.[*]

[*]http://www.abplive.in/sports/ms-dhoni-says-he-consults-virat-kohli-during-matches-431672

While working on projects, I have often been consulted by my seniors and asked for my opinion. Is it because they lacked the experience? Definitely no. Instead they valued the fact that my opinion might bring another dimension to the entire scheme of things. It is extremely important to understand the other's point of view. Every person you meet knows something you don't. This makes members of the team feel valued and wanted in their own roles.

Situational leadership

In this case, the leader changes his style depending on the situation and adjusts it depending on the limitations presented to him. Virat, though aggressive, understands that in any match even a good delivery can be hit for a six. In such circumstances, he needs to restore confidence in his bowlers and speak to them in an assuring manner. Virat as a captain has so far led the side with a passion to win every game and believes in picking the wickets regularly even at the expense of a few runs.

Transformational leadership

In this case, the leader works towards motivating the team and transforming them into a single cohesive unit which believes in winning in every given situation. These leaders focus on empowering their team members through their own beliefs and strengths. Yet again Virat shows his skills to be a transformational leader if we look at the performance of R. Ashwin, K.L. Rahul or Karun Nair. These players' performances definitely peaked under Virat's captaincy. Ashwin finished both 2015 (62 wickets in 9 matches) and 2016 (72 wickets in 12 matches) as the leading wicket taker in the Test matches, including five 10-wicket hauls. His record under Virat's captaincy reads as follows:

Table 11

Ravichandran Ashwin: Performance under Virat's captaincy

	Mat	Inns	Overs	Mdns	Runs	Wkts	Avg	Econ	SR	5Ws	10Ws
2015	9	17	376.4	94	1,067	62	17.2	2.83	36.4	7	2
2016	12	23	584.4	102	1,721	72	23.9	2.94	48.7	8	3
2017	3	6	183.5	47	478	21	22.8	2.60	52.5	1	0

Notes: Mat: matches; Inns: innings; Overs: overs bowled; Mdns: maidens; Runs: runs conceded; Wkts: wickets taken; Avg: average runs per wicket; Econ: economy rate; SR: strike rate; 5Ws: five wickets in an innings; 10Ws: 10 wickets in the match

K.L. Rahul too has emerged as a consistent performer in the longer version of the game. He narrowly missed a well-deserved double century in the Chennai Test against England (December 2016) when he was out for 199. His Test record under Virat's captaincy reads as follows:

Table 12
K.L. Rahul : Performance under Virat Kohli's captaincy

Year	Mat	Inns	NO	Runs	HS	Avg	100s	50s
2015	4	8	0	252	110	31.50	2	0
2016	7	9	0	539	199	59.88	2	1
2017	3	6	0	227	90	37.83	0	3

Notes: Mat: matches; Inns: innings; NO: not outs; HS: highest score; Avg: average

Karun Nair has been an exception of a sort. He managed to score an unbeaten triple century in only the third match of his Test career in Chennai against England (December 2016). The performances of these players imply that Virat is well on his way to build the core of the future Indian cricket team. As a true leader, he is driving others to recognise their strengths and perform to the best of their abilities. In some ways, it is reminiscent of the early days of Dhoni's career as captain when he backed young talents like Suresh Raina, R. Ashwin, Ravindra Jadeja and Virat himself who are all proven match winners today.

Virat always wishes to be in the action, whether it is shining the ball or aggressively responding to the opponent. It is extremely difficult to keep him out of the game. On being appointed the captain in limited overs cricket, he had this to say:

This is probably the biggest day in my life and I am very thankful to MS Dhoni for giving me this opportunity, for thinking I am worthy of taking the responsibility forward and I am very grateful to his contribution in the process. It's a very special moment in my life, it's a lot of responsibility and something I am really looking forward too. I didn't realise when the transition happened in my own head starting off as a player who just wanted to play for India and now having the responsibility to be captain in three formats....[*]

Dhoni has also been full of praise about Virat's ability to lead the side:

So I feel that he was always pushing himself—when it comes to fitness, reading of the game, execution of his plans—I feel that's what makes him very special....

After that, it's how you lead your team and since he has the experience of leading RCB and also now that he is the Test captain for the more than a year, I feel in a way he has groomed himself looking at all the challenges that he had to face. I feel that he has done an exceptional job and that he has a very bright future ahead of him when it comes to being the captain of the teams.[**]

Even at the moment of assuming captaincy, Virat was quite clear about the responsibilities that lay ahead and the journey that he had covered so far and what would come next. As a

[*]http://www.firstpost.com/sports/ms-dhoni-will-always-be-my-captain-virat-kohli-on-leadership-msd-the-batsman-and-more-3196556.html
[**]http://www.firstpost.com/sports/ms-dhoni-says-virat-kohli-will-make-a-good-captain-for-india-in-all-three-formats-2966002.html

professional, we should keep our career trajectory in mind, whether we are in the corporate or the sports ground.

The one thing that Virat has shown after Dhoni's stepping down from captaincy is the enormous respect that he has for the former captain. Likewise Virat is seen as a performer within the team and is well respected. It is this mutual respect that can help build a strong Team India for the future. In a similar manner, in any corporate environment, if team members respect each other, it can help bring people from different experiences and backgrounds together and build a more cohesive unit. It is important to acknowledge the experience of different players if one has to extract the best out of them.

One of the reasons of bringing back Yuvraj Singh to the ODI and T20 team was his experience of playing against the English attack. Yuvraj last played ODI for the Indian team in 2013. However, he was quick to justify the faith of the Indian skipper by scoring a century and sharing a record stand with Dhoni in the second ODI of the series against England in January 2017.

If someone wears the Indian cricket team jersey, he must have worked hard to earn his place in the team. It is important then for the captain to act as an enabler to improve the individual's performance and not just act as a boss.

How is Virat's captaincy different from Dhoni's style?

There is no doubt that Dhoni is arguably one of the greatest ambassadors of the modern game. His record as captain along with his calm approach has earned him the respect of fans; however, his sudden decision to step down from captaincy paved the way for the Virat era of Indian cricket.

There are subtle differences in the leadership style of the

two players which make them significantly different from one another.

Mr Cool versus Mr Aggressive

Dhoni and Virat have a completely different body language when it comes to managing themselves on the field. Mahendra Singh Dhoni comes across as someone who is extremely calm whereas Virat is known for his aggressive responses to the opposition both on and off the field. Even in terms of field placements and using bowlers, Dhoni has always preferred to adopt a cautious approach. For example, in his captaincy, both Ashwin and Ishant Sharma have been largely used for containing the flow of runs whereas Virat has used them as attacking players. During the tenure of Dhoni as captain, Ashwin has always been used after power play in the limited overs cricket, whereas Virat has preferred to use him during the initial overs. Similarly, in the case of Ishant, Dhoni looked at him more for containing the flow of runs.

*A clear-cut strategy**

Virat has been clearer about his team strategy, whether it is playing with a five-bowler strategy or giving opportunity to new players such as Karun Nair and K.L. Rahul. On the other hand, Dhoni has always preferred to go ahead with a defined set of players. Virat has believed in playing a team depending on the situation which has resulted in opportunities for many youngsters. He is also open to the inclusion of seniors like

*http://indianexpress.com/article/sports/cricket/you-think-of-ms-dhoni-and-the-first-word-that-comes-to-your-mind-is-captain-virat-kohli-4463418/

Yuvraj Singh who has been recalled for the ODI and T20 series against England.

Power of youth versus age-old wisdom

Virat has the power of youth and performs well under pressure. A captain should be selected keeping in view his performance and the long-term future of the team. Virat definitely fits the bill. His aggression on the field and his body language as an aggressive young lad clearly gels with the Indian youth. Moreover, considering he is just 28 years old, having him as the captain for all the three formats augers well for the future. At the same point of time, the presence of Dhoni in the dressing room and in the field will imply that Virat has someone to seek advice from.

Post Dhoni's decision to resign from captaincy, Virat has been quite effusive about the captain under whom he made his debut. In his words:

> He [Dhoni] will always be the person, who guided me initially and gave me opportunities. He gave me ample time and space to grow as a cricketer, saved me from getting dropped from the team many a times. Obviously, these are massive shoes to fill. You think of M.S. Dhoni and the first word that comes to mind is captain! You don't relate [to] M.S. Dhoni in any other way. For me he is always going to be my captain.[*]

It is this humility that sets him apart as a leader. Despite

[*]http://indianexpress.com/article/sports/cricket/you-think-of-ms-dhoni-and-the-first-word-that-comes-to-your-mind-is-captain-virat-kohli-4463418/

being appointed the captain and replacing Dhoni, Virat remembers his roots and the contribution that Dhoni has made as a captain and ambassador to the Indian cricket.

Virat's achievements as the captain

Let's take a look into Virat's achievements as captain so far to understand the impact that he has made:

1. After 22 matches, he has the highest win percentage among Indian captains who have led the side in five or more games.
2. He is the second player in Test history to score century in both the innings of his debut match as a captain after Australia's Greg Chappell.
3. He is also the youngest captain to score centuries in both innings of his debut match as a captain.
4. He is the first Indian captain to win a series outside India after losing the first match when he led the team to a 2–1 victory over Sri Lanka in 2015. At 26 years and 300 days, he is also the youngest Indian captain to win Test series outside India.
5. He is the fastest cricketer to reach 7,000 ODI runs in just 161 innings.
6. He scores a century every 6.33 innings in the ODIs which is the highest for any Indian cricketer.

When the best batsman in the world is also the captain of the side, can any force possibly stop him? He is undoubtedly one of India's finest captains ever; however, he still has a long way to go. Having Virat as the captain in all the three formats is probably the right way ahead as it would help him in building a team, keeping World Cup 2019 in mind. Can he repeat his success of

the Under-19 World Cup 2008 in 2019 as well? Will he be able to become the only Indian captain to win both the under-19 and ICC Cricket World Cup? The start does look promising.

The Kohli Way of Leading Life

Life is like riding a bicycle. To keep your balance, you must keep moving.

—Albert Einstein

Seize the opportunity

Carpe diem or 'seize the day' is a Latin aphorism implying that it is extremely important to live in the current moment and try to do the best in that. Often, as individuals, we tend to feel that life has been unfair with us at times. In those moments, we tend to overlook the opportunities that life has presented to us at that juncture.

There is a lot to learn from this approach towards life. Even in terms of the life that professionals lead, living one day at a moment helps in focusing on the objectives in hand. This, in turn, leads to improved productivity at the workplace. If we carry a baggage from the past, it will always hold us back and not let us perform.

Let us consider a hypothetical situation:

Shiv was preparing for the IIT-JEE examination with utmost dedication for the last two years. His results have also been consistently good which implied that he should get a coveted seat. However, on the day of the result, he did not make it to the IITs.

Many of us have gone through similar experiences in our lives where we have often put in the best of efforts and yet not got the right results. How do we react in such a situation? Should we hold on to our disappointment and keep cursing the past? The right approach will be to look around us and find the next best opportunity.

If we consider his debut in ODI cricket, it was a result of the injury to the regular opener Virender Sehwag. Here again he seized the opportunity with both hands, and today he is one of the most successful cricketers in world cricket. Opening is not his forte, but he did not let go of the opportunity. Though he did not fare well in that match (12 runs of 22 balls), yet he had already shown a positive intent and attitude. It is small incidents like these which make the difference in the long run.

LEARNING TIP

Evaluate your situation carefully and always be prepared to seize an opportunity. Never give up.

Virat's approach towards life also deals a lot towards having a positive attitude. It is about overcoming the odds with a clear uncluttered mind. Living in the moment allows one to achieve that!

If we look at a few of his quotes, we can further understand his philosophy towards life:

Whatever you want to do, do with full passion and work really hard towards it. Don't look anywhere else. There will be a few distractions, but if you can be true to yourself, you will be successful for sure.[*]

Self-belief and hard work will always earn you success.[**]

The more centuries that I am able to score, the happier I will be.[***]

I love tattoos. And mine symbolise who I really am. I have a Samurai on my left arm. At a subconscious level, I connect to this warrior and model myself on his discipline, skills and honour. There is also a tribal tattoo and a Chinese symbol of faith. I have seen a lot of people getting tattoos just because it's a trend.[****]

Nothing extraordinary happens to a cricketer if you time his career—which is very short.[*****]

It is important to know who and what matters in your life. Not everyone deserves to be a priority in your life. As professionals, we too can adopt this methodology in our office life by breaking the eight-hour day into four different slots of two hours each. In each of the two hours, we can then schedule our activities and definitely increase the productivity.

In order to further analyse and understand Virat, it is

[*]http://startuphyderabad.com/learnings-entrepreneur-kohli/
[**]https://successstory.com/inspiration/famous-success-quotes-part-8
[***]https://quotefancy.com/quote/1752046/Virat-Kohli-The-more-centuries-that-I-am-able-to-score-the-happier-I-will-be
[****]http://www.inspiringquotes.us/author/2660-virat-kohli
[*****]http://indiatoday.intoday.in/story/virat-kohli-interview-about-india-vs-pak-win-in-asia-cup/1/179085.html

important to do a SWOT analysis on him. SWOT analysis (alternatively SWOT matrix) is an abbreviation for strengths, weaknesses, opportunities and threats. This methodology is used to evaluate those four elements of a project or scenario. If we perform a SWOT analysis on Virat, it will look something like this:

Figure 7
SWOT analysis of Virat Kohli

If we try to analyse the SWOT diagram, we can see that Virat is already improving on his weak areas whereas his strict fitness regime and practice schedule is meant to take care of the possible threats.

Managing relationships

> I feel only my friends and family need to know what is
> happening in my personal life.
>
> —*Virat Kohli**

Relationships are the stepping stone to success, whether it is personal or professional. How we interact with others not only makes a difference in our lives but also the ecosystem in which we live. For instance, let us consider a scenario:

Shiv has recently been promoted.

Scenario 1: *He receives the intimation through email.*

Scenario 2: *His manager calls him and intimates the news.*

Scenario 3: *In front of all his teammates, his manager congratulates him and praises him for the work that he has done. He is then intimated about his promotion.*

Clearly scenario 3 is a definite game changer when it comes to managing relationships at the workplace. It helps in building the personal connect at the workplace. For instance, most of us spend over 10 hours a day at the workplace. In case you are a student, you will probably be spending 10 hours or more with your college friends. In such a scenario, it is extremely important to build relationships at our workplace as working will become fun if we have friends around us. The body language, the smile, the warmth and the happiness for someone else's success is what determine relationships.

*https://www.brainyquote.com/quotes/quotes/v/viratkohli623215.html

Our reaction to situations is also a major reason into how people tend to perceive us. Sometimes in the midst of stress, we react unfavourably to even the smallest of issues. It is equally important to manage a proper work–life balance. How to manage it in the midst of stress?

Perhaps if we look at the manner in which Virat manages his relationships, there is a lot to learn from it. In fact, apart from managing his investments and cricket, he is also a person who deeply values his relationships with everyone. We must understand that cricket is a team game. To ensure a favourable result, any team must perform as a single cohesive unit. Let's try to look at his philosophy.

Virat's relationship with his coach

Arguably, the one relationship that has made Virat one of the best cricketers in the modern era is the bond with his coach. Virat sees his coach as a mentor and deeply values the association. Self-admittedly, at times, he is still afraid of his coach scolding him.

When his coach Rajkumar Sharma was awarded the Dronacharya Award, Virat took to Twitter to congratulate his coach.

> Congratulations Raj Kumar Sir. All the hard work behind the bigger picture never gets noticed. I am delighted for you on getting the Dronacharya Award.[*]

In fact, Virat has always attributed his success to his coach and mentor and the admiration seems to be mutual. Recently, when James Anderson questioned the technical deficiency in Virat's

[*]http://www.cricketcountry.com/news/virat-kohli-delighted-for-his-coach-raj-kumar-sharma-on-receiving-dronacharya-award-485684

technique, Rajkumar came out openly in support of his protégé. In an interview to a news agency, he told the following:

> This is a childish statement from Anderson. What has he done in the matches that he has played? He is also not getting wickets in India. He may be a good pacer but he has to also take wickets in India. Taking wickets in England can't be a parameter to term someone great. Just wanted to remind Anderson that Virat has five Test hundreds in Australia which produces the fastest pitches.[*]

Well, clearly, the coach and the protégé share a relationship that can counter any rival, both on and off the pitch.

LEARNING TIP

Value your mentors and maintain a
good relationship with them.

Virat's relationship with his family and friends

Virat was always close to his dad Prem Kohli. A criminal lawyer by profession, his father wanted to do everything to fulfil Virat's dream of playing cricket. However, Virat lost his father at the tender age of 18. Virat is also extremely close to his mother, Saroj. In fact, he makes it a point that whenever he is at home, he should have home-made food. He is also close to his brother and sister and routinely posts images on social media with his nephew.

> When we work in a highly demanding environment, we often overlook our personal relationships, sometimes even

[*]http://www.firstpost.com/sports/virat-kohlis-childhood-coach-rajkumar-sharma-slams-childish-james-anderson-3156130.html

forgetting to call our parents. Virat carries the burden of the nation's expectations, yet always has time for his family. There is so much to learn here. Sometimes making a quick call of five minutes to your parents or brother or sister can bring a smile in their lives. Never forget your roots or your family. It is your roots and origin which define you. Just like every normal person, Virat too values his friends a great deal. Among his close friends is TV anchor Karan Wahi who also hails from Delhi.

Virat Kohli is extremely fond of animals and often posts selfies with his pet dog Bruno. Prior to this, he had a Pomeranian and a Golden Labrador. He even posted a video on Facebook with his pet Bruno on the bad impact of crackers on pets during Diwali. This truly shows the compassionate nature of this star cricketer.

LEARNING TIP

One should never let go of our close friends in life, regardless of the success that we achieve.

Virat's relationship with his teammates

Virat is revered as a captain and as a player by his teammates. He has earned that respect not just by his performance but also in the manner in which he has conducted himself, both on and off the field. Indian off-spinner Ravichandran Ashwin has this to say:

> Whenever he hands the ball over, I can be rest assured that I will get what I want and I am always backed. And that's something that's not just between me and him.

I think he has done that with everybody in the team. Whoever he has backed, he has backed them and helped them cross barriers.*

This speaks volumes about the way in which he backs his teammates. Hence, it is natural for the players to respond positively whenever he will need them. Yuvraj Singh, who was called back to the squad for the ODI series against England, has also been effusive in his praise for the young skipper. On scoring the match-winning century in the second match of the series, Yuvraj had the following to say:

Self-confidence is always there when you have the backing of the team and captain. I think Virat has showed a lot of trust in me and it was very important for me that people in the dressing room trust me.**

Yet again there is so much to learn here. Let's consider a scenario:

Satish has recently been given the task to launch a payment wallet for his company. His boss Iqbal has given him complete authority and even supports him in front of the management when he makes a mistake. Buoyed by the support, Satish worked more comfortably and delivered the project on time.

This is a very common practice in an office. If employees are encouraged for their performance by the leadership, productivity naturally improves.

*http://indianexpress.com/article/sports/cricket/virat-kohli-has-always-backed-his-team-mates-helped-them-cross-barriers-r-ashwin/
**http://www.hindustantimes.com/cricket/how-virat-kohli-inspired-yuvraj-singh-to-drop-retirement-plans-in-time-of-crisis/story-hRCzrwwf3RfvXbvz9gNC1I.html

Virat's relationship with his opponents

During the IPL game in 2013 between Kolkata Knight Riders and Bangalore Royal Challengers, the two captains (Gambhir and Kohli) had a spat and used objectionable gestures at each other. But after that, Virat acted with a lot of maturity and downplayed the incident in media and press conferences.

It is important to resolve differences that may arise within the team in any organisation. If teammates show a sign of maturity in handling such a situation, it can lead to better levels of trust within the team and prevent conflicts while managing such situations.

In a similar manner, he intervened to prevent a major tussle between Ravichandran Ashwin and James Anderson in the India–England series in 2016. The conflict was a result of the comment by Anderson about Virat's technique. On the day, Virat scored his career's best knock of 235, Anderson had remarked the following:

> I am not sure if he [Kohli] has changed. I just think any technical deficiencies he has got are not in play out here. The wickets just take that out of the equation. There is not that pace in the wicket to get the nicks, like we did against him in England—with a bit more movement.[*]

Virat acted as the peacemaker and helped in pacifying the heated exchange between Ashwin and Anderson at the Wankhede Stadium. This was quite uncharacteristic of the aggressive Virat that we know of and reflects signs of him maturing as an individual. It is a gesture like this that helped in retaining the good spirit in which the game was being played between

[*]http://indianexpress.com/article/sports/cricket/virat-kohli-vs-james-anderson-who-is-saying-what-on-controversy-4426596/

the two sides.

The important lesson to learn here from Virat is that it is crucial to respect your opponents. It is all right to compete with them on the ground but only with respect to the game. Similarly, in the corporate sector, the focus should be on building better products and not on demeaning opponents.

Virat also equally cherishes his friendship with opponent players. For instance, he shares a great rapport with South African cricketer A.B.de Villiers. He posted a picture of the two mentioning the following:*

> Throwback to a very very special picture. Very few people in my life have connected with me like my dear friend AB and I share the most wonderful bond with this great man. So much to learn from him all the time. If you ever want a role model for any walk of life, he is IT.

—@virat.kohli, 13 September 2016

Clearly, Virat doesn't hold back when it comes to praising or supporting someone.

LEARNING TIP

Show respect to your opponents, and it will make you the leader you ought to be.

The evolution of Virat and the way ahead

There are several reasons for Virat's success. His dedication and devotion along with the guidance of an able coach has

*http://indianexpress.com/article/sports/cricket/virat-kohli-calls-best-friend-ab-de-villiers-role-model-in-every-walk-of-life-3029743/

catapulted him to the pinnacle of world cricket. From being a chubby Delhi boy to arguably the world's best batsman, Virat Kohli has definitely come a long way in his career.

If we look at the career trajectory of Virat, we can divide it into five distinct stages. Stage 1 (Virat 1.0) ended with his winning the Under-19 World Cup while Stage 2 (2008–11) started with his international debut and marked a phase when Virat was questioned about his skills and attitude in the early part. Stage 3 (2011–14) marked the most decisive phase in Virat's career where he evolved into the most entertaining and consistent cricketer in the world and Stage 4 (2015–16) marked his coming of age as the Test captain and leading a young side to being the number one side in the Test cricket.

Figure 8
Career trajectory of Virat Kohli

| Till 2008 | 2008 to 2011 | 2011 to 2014 | 2015 to 2016 | 2017 onwards |

Virat 1.0
Young Virat performs well in domestic cricket and wins Under-19 Cricket World Cup.

Virat 2.0
Virat gets selected into the national team; struggles a bit in the early days in international cricket.

Virat 3.0
He emerges as the most consistent performer and one of the best players in world cricket.

Virat 4.0
He is appointed as the captain of the Test team and leads the side to number one ranking. Personally, has a dream 2016 with the bat.

Virat 5.0 beyond
Virat is appointed as the captain in all three formats. He has the responsibility to build a new team and lead it to World Cup glory.

Virat 5.0 and beyond

The resignation of Dhoni from captaincy at the start of 2017 implies that the coming years will be more challenging for Virat as he will have to live up to the expectations of both captaincy and his stature as one of the best batsmen in the world. Virat has so far done well as far as Test captaincy is concerned. As ODI and T20 captain, he has started on a promising note by winning his first series in both the formats. However, it will not be an easy road ahead.

While his records in T20Is and ODIs have been outstanding, his ability to play the seaming delivery in Test cricket will once again come under the scanner during overseas tours. Though he has scored significant volumes of runs in 2016, one must also keep in mind that most of his runs have come on subcontinental pitches which are known to be batting friendly. He will have to lead the side on difficult tours like Australia and also build the team for World Cup 2019. As a senior in the side, Virat now has the additional responsibility of mentoring the young guns who make their way into the national side. Players like Sanju Samson and Karun Nair will look up to Virat just like he used to look up to Tendulkar and Dhoni when he started his career. He will have to support and guide these cricketers to ensure that Indian cricket is in safe hands when he decides to call it a day in future.

Virat has an attitude which helps him improve after every single game that he plays. As a captain, he will now have to focus as much on field placements and bowling changes as on his own game. Few cricketers have been able to perform with such consistency with the additional burden of captaincy on their shoulders. His ability to score under pressure will be tested

when he leads the side in the Champions Trophy in August 2017 and the much awaited World Cup 2019. The glory of winning the IPL has so far eluded Virat. Even after nine seasons of playing the tournament, he has so far been unsuccessful in lifting the trophy. As a fierce competitor and a student of the game, Virat would like to achieve this feat sooner rather than later.

Virat has been fortunate not to have suffered any major injury in his career so far. It will prove to be a challenge for him whenever he endures such a hurdle in the future. He will have to ensure that he maintains his fitness and does not suffer any unnecessary wear and tear which might cut short his glorious run. It remains to be seen if Virat can sustain his form over the coming years and one day surpass the records set up by the legend Sachin Tendulkar. Will Virat be remembered as one of the greats to have played the game? He certainly has the talent and the potential to achieve the same.

There is little doubt that Virat will perform to the best of his abilities in the near future as well. Here's hoping that he is able to recreate the magic of World Cup 2011 in 2019! Virat Kohli will continue to inspire us into giving our best and achieve what we deserve.

Appendix

Virat's achievements so far

1. Fastest century by an Indian cricketer in ODIs (in 52 balls)
2. Fastest Indian to reach 1,000 runs in ODIs
3. Fastest in the world to reach 7,000 runs in ODIs
4. Fastest in the world to reach 25 centuries in ODIs
5. Fastest in the world to reach 1,000 runs in T20Is
6. First cricketer to score three centuries in his first three innings as a Test captain
7. Fastest captain to score 1,000 ODI runs

Awards and recognitions

1. ICC ODI Player of the Year: 2012
2. ICC World ODI XI: 2012, 2014 and 2016 (Captain)
3. BCCI's Polly Umrigar Award for International Cricketer of the Year: 2011–12 and 2014–15
4. Arjuna Award: 2013
5. CEAT International Cricketer of the Year: 2011–12 and 2013–14
6. Padma Shri (the fourth highest civilian award in the Republic of India): 2017

Acknowledgements

This book would not have been possible without the blessings of my late mother (Dr Lina Bhattacharya). She had been instrumental in guiding me, and whatever I achieve in life is owing to her.

I would like to thank my father (Mr Vishwa Nath Bhattacharya) and my elder brother Abhishek who have constantly supported me through every phase of my life. I would also like to express my gratitude towards my friends Prashant, Biswarup, Sujit, Mugdha, Vikram, Dushyant, Pritam, Priyangi, Radhika, Kushan and Anuradha for putting their faith in my abilities at all times.

Finally, I would like to express my gratitude to my publisher Rupa Publications, the editorial team (Shreya Chakraborti and Elina Majumdar) and my commissioning editor Shambhu Sahu for giving me the opportunity to write this book.

Printed in Great Britain
by Amazon

44628707R00084